the art of personal imagery

Expressing Your Life Through Collage

corey moortgat

NORTH LIGHT BOOKS

CINCINNATI, OHIO

W9-CAW-759

The Art of Personal Imagery Copyright © 2007 by Corey Moortgat. Manufactured in China. All rights reserved. The patterns and drawings in this book are for personal use of the reader. By permission of the author and publisher, they may be either hand-traced or photocopied to make single copies, but under no circumstances may they be resold or republished. It is permissible for the purchaser to make the projects contained herein and sell them at fairs, bazaars and craft shows. No other part of this book may be reproduced in any form or by any electronic or mechanical means including information storage and retrieval systems without permission in writing from the publisher, except by a reviewer, who may quote a brief passage in review. Published by North Light Books, an imprint of F+W Publications, Inc., 4700 East Galbraith Road, Cincinnati, Ohio 45236. (800) 289-0963. First edition.

11 10 09 08 07 5 4 3 2 1

Library of Congress Cataloging-in-Publication Data

Moortgat, Corey.
 The art of personal imagery : expressing your life through collage / Corey Moortgat. -- 1st edition.
 p. cm.
 Includes index.
 ISBN-13: 978-1-58180-990-9
 1. Photographs--Conservation and restoration. 2. Photograph albums. 3. Scrapbooks. 4. Collage. I. Title.
 TR465.M62 2007
 771'.46--dc22
 2007014248

Distributed in Canada by Fraser Direct
100 Armstrong Avenue
Georgetown, ON, Canada L7G 5S4
Tel: (905) 877-4411

Distributed in the U.K. and Europe by David & Charles
Brunel House, Newton Abbot, Devon, TQ12 4PU, England
Tel: (+44) 1626 323200, Fax: (+44) 1626 323319
E-mail: postmaster@davidandcharles.co.uk

Distributed in Australia by Capricorn Link
P.O. Box 704, South Windsor, NSW 2756 Australia
Tel: (02) 4577-3555

Metric Conversion Chart

to convert	to	multiply by
Inches	Centimeters	2.54
Centimeters	Inches	0.4
Feet	Centimeters	30.5
Centimeters	Feet	0.03
Yards	Meters	0.9
Meters	Yards	1.1
Sq. Inches	Sq. Centimeters	6.45
Sq. Centimeters	Sq. Inches	0.16
Sq. Feet	Sq. Meters	0.09
Sq. Meters	Sq. Feet	10.8
Sq. Yards	Sq. Meters	0.8
Sq. Meters	Sq. Yards	1.2
Pounds	Kilograms	0.45
Kilograms	Pounds	2.2
Ounces	Grams	28.3
Grams	Ounces	0.035

Editor
Jessica Strawser

Art Direction and Design
Amanda Dalton

Production Coordinator
Greg Nock

Photographers
Christine Polomsky
and Tim Grondin

Photo Stylist
Louis Rub

fw
F+W PUBLICATIONS, INC.
www.fwbookstore.com

Dedication

I'd like to dedicate this book to my family.

To my husband, Jason, who has opened his mind to an artistic wife who I'm sure is quite the opposite of the woman he imagined marrying ten years ago. He has put up with my trips to antique shops, my eBay addiction and my constant collection of vintage ephemera, all in the name of my artwork. And he has embraced this passion of mine so well that he is now as adept as I am at spotting that rusty filigreed bit of metal or that vintage diary with the gorgeous handwriting. Thank you, Jason, for your patience and support.

To my son Riley, who has become one of my biggest muses and has helped me move my artwork in an entirely new direction. He is such an inspiration just by "being." I hope he will come to tolerate and perhaps even appreciate his eccentric, artistic mother.

To my son Noah, who was born while this book was in production, who I know will bring new life to my artwork, with new energy and his own unique existence. I can't wait to see what changes he will bring to my life, both artistically and otherwise.

And to my parents, Dorothy and Roger, and sisters, Katie and Julia, who have always supported me and encouraged me in my artistic endeavors. I would never have continued to pursue this path had I not felt supported throughout my life.

Acknowledgments

As you may gather from your reading, there was a lot going on in my life during the writing of this book. When I decided to go through with it, the only thing on my plate was taking care of my son, Riley. But during the course of the writing, I found out that I was pregnant, due two weeks after the deadline for the manuscript, and that we would be making a cross-country move six weeks before the deadline. So, needless to say, it was a tumultuous time in my life! The book could not have come together without the help of several people. I'd like to thank the following:

- Tonia, for opening the door and encouraging me to submit a proposal.
- My blog readers, for helping me formulate an idea for the theme of the book.
- My mother, for spending a week at our new house a month before my manuscript was due, caring for Riley while I pounded out as much as possible.
- Jessica, my editor, for supporting me and working with me, despite my hectic schedule and limitations.
- And all of you who wrote to me, telling me how excited you are about this book—your encouragement really helped keep me going when things seemed overwhelming!

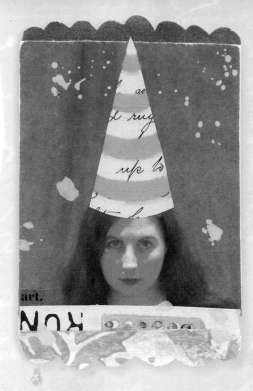

About the Author

Corey Moortgat is a collage artist who lives in Jacksonville, Florida. She has been interested in art since childhood, when she spent many an hour drawing, painting and generally "making." She has a bachelor's degree in fine arts and a master's in art therapy. It was in graduate school that she discovered her passion for creating art that is personal and meaningful. She worked as an art therapist for a few years, but was unhappy with the politics of the mental health field, so switched careers to become a custom picture framer for about ten years, until the birth of her son.

She discovered collage and mixed media in 1999 and hasn't looked back since. Her favorite materials are personal photos, old photos, nudes, antique children's items and any vintage ephemera she can find. Her work and writing have been featured in several magazines and books.

She has been married to her husband, Jason, since 2003. They have two sons: Riley, who was born in 2005, and Noah, who was born soon after she finished writing this book. She draws great inspiration for her artwork from her family, and hopes her work will inspire them and move them in years to come. Visit her online at www.coreymoortgat.blogspot.com and www.picturetrail.com/coreymoortgat.

CONTENTS

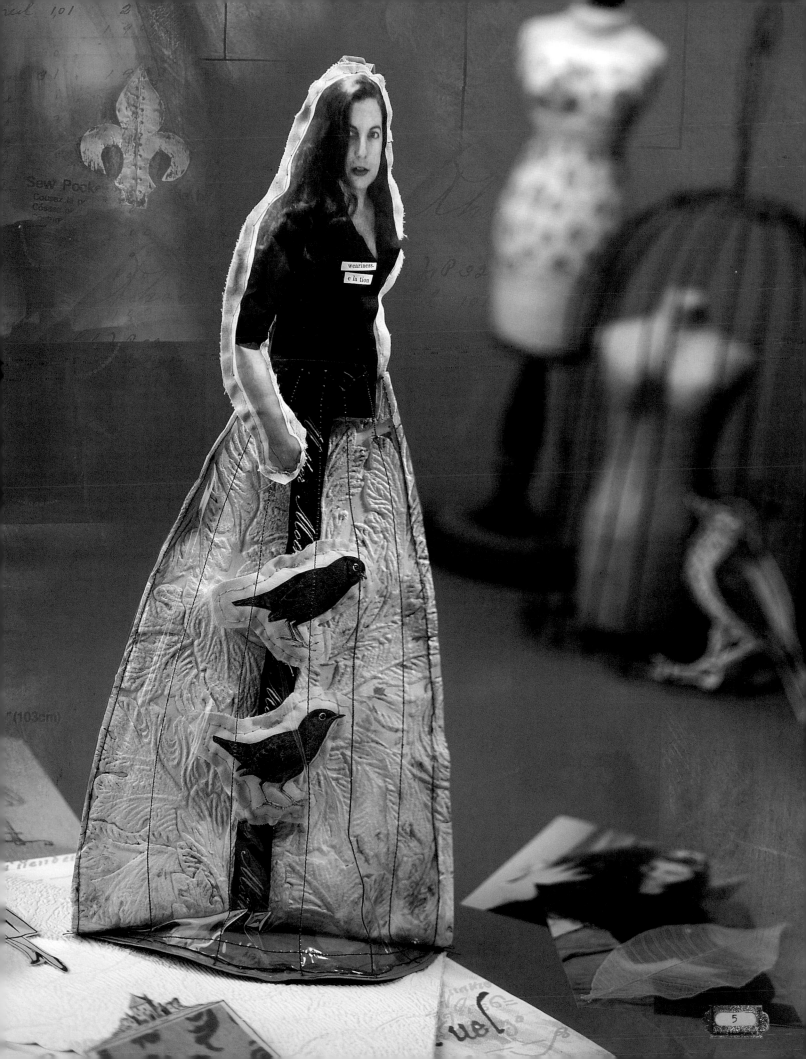

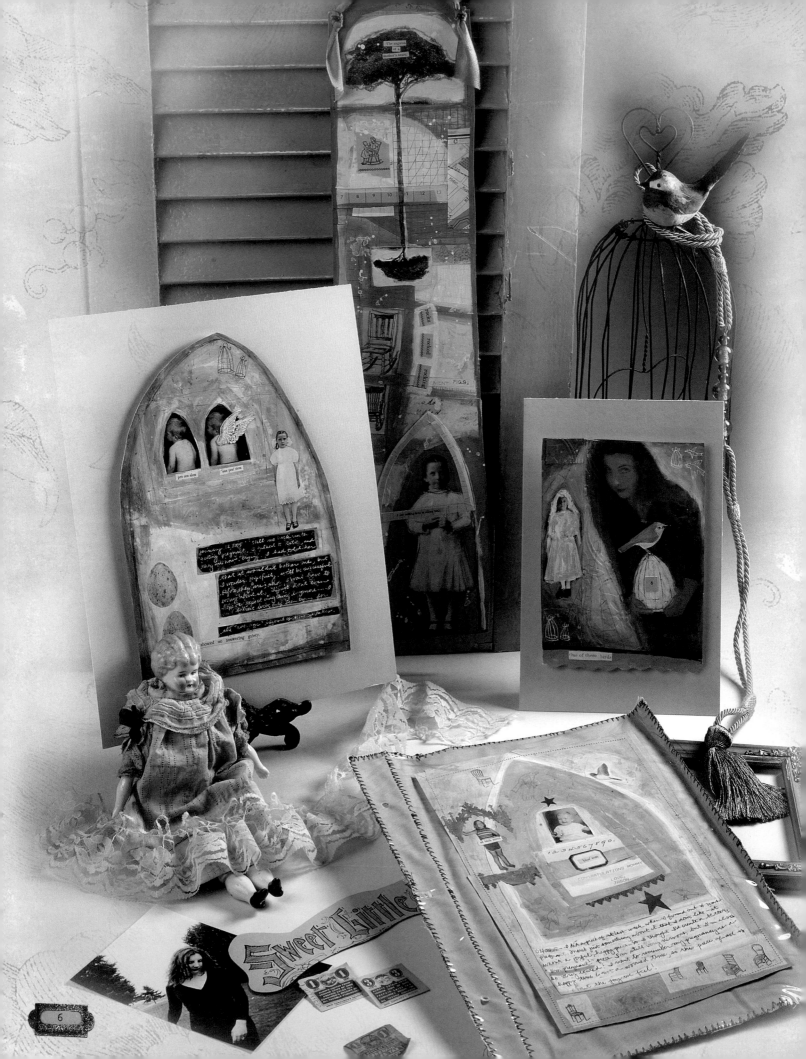

inTRoDuctIon:
make it meaningful

It's hard not to love the collage movement that has taken the art world by storm the last few years. There's so much gorgeous artwork out there; you can get caught up for hours admiring all the delicious eye candy. Not to mention all the great imagery available—vintage photos of adorable children, gorgeous butterfly wings, ornate crowns, playing cards, dominoes—and inspiring sentiments—"Wish upon a star," "Dream," "Imagine." But is collage strictly a feel-good artform meant to be sweet and pretty and mildly inspiring? Or can it be more?

I think it can. I think it can be intimate and soulful and meaningful to your life. I think every piece you create can tell a story about your daily struggles and triumphs. I think that as artists, we haven't been challenging ourselves enough. It's relatively easy to create a fun, playful collage that doesn't have a lot of personal meaning behind it, but it takes strength and courage to go beyond that and make your artwork self-expressive.

Don't get me wrong: I've definitely made my share of pretty, frivolous pieces. I think we all have; it's how we learned this style of art. But, looking back at these pieces, don't you have to admit to yourself that they have almost no personal significance— that they fail to speak of you or your life?

I know this all might sound harsh. And really, if you enjoy doing less personal art like I've described, if it brings you joy and happiness, I honestly don't mean to offend. There's definitely something to be said for having fun and keeping things light. But this book is for artists looking to push their boundaries, for those who want to gain some insight and make their collage more meaningful.

I began to take my artwork to a more personal level a few years ago. While I liked the look of what I was creating, I felt that my pieces seemed a little hollow. Nothing about them really said "Corey," and as a former art therapist, that bothered me. Where was my story, my soul? I was someone who believed in using art to express emotions and work through problems, and who had been trained to help others realize its therapeutic effects. Yet in my own work, my story, my soul was missing. I was doing nothing to gain insight into myself or to document my life. I was simply making pretty pictures.

This revelation came around the time I was getting married. I knew I would forever regret it if I didn't illustrate that event in some way other than a standard photo album. Yet I had never done collage art with the purpose of documenting something specific. Sure, I could have done a nice piece with vintage photos of women in wedding dresses and perhaps used game tiles to spell out the date, but that would have done nothing to help me remember the emotions, the excitement, the story of those days.

So instead, I decided to face my fears and create a wedding journal. I made a list of all the memories I wanted to document while they were fresh in my mind, and I went to work. I forced myself to figure out ways to incorporate modern wedding photos and other memorabilia into my more traditional vintage collage style. It was tough, but the end result was both incredibly personal and incredibly satisfying.

Now, virtually all my artwork has some personal, journalistic aspect to it. Soon after the wedding, I began documenting our struggle to become pregnant, followed by the birth and life of our son. As you will see in many of the projects in this book, I am now illustrating my second pregnancy and my ranging emotions and insecurities about being a good mother to two children. A fellow artist once told me, "Your family is so lucky—you are giving them such a gift with this art." I had never thought of it that way, but now I see how true this is.

Throughout my artistic journey, I've come to develop a style that melds the genres of both traditional collage art and scrapbooking, yet doesn't fit the mold of either one. I hope that in reading this book you'll find techniques, ideas and inspiration that will help you achieve your own trademark style that realizes the goals of your own work.

By mastering some simple techniques and challenging yourself to do a little self-exploration, you can gain the tools to make your collages speak of you and your life. I'll show you how to incorporate modern photos and mementos into your work, how to find and use symbolic old photos, how to discover your own personal icons, and how you can take easy steps to create a beautiful aged and layered look with lots of depth. What a gift it will be for your family—and for yourself—to have artwork that chronicles your life and glows with your essence. And you don't have to abandon everything you already know about collage. In fact, you'll continue to use it—only now it will be infused with personal intimacy and significance.

So come on, challenge yourself! Push yourself beyond impersonal collage and come out on the other side with meaningful artwork that chronicles your life and screams of you!

trap pings

BASiC COLLaGe SuPPLiEs

Adhesives

Glue Stick: Glue stick is my collage adhesive of choice (mostly because I don't like getting my hands dirty or sticky!) Make sure the glue covers the back of your collage elements completely, even on detailed edges, and always use an acid-free style to help preserve your artwork.

Tacky Glue: Tacky glue works well for attaching lightweight embellishments, such as pieces of cardboard or fabric. It adheres fairly quickly and holds well.

Multipurpose Cement: If you need to adhere a heavier or more unusual item, such as one made from metal or wood, use a multipurpose cement. These cements are specifically made to adhere certain materials, so check the label before you decide which one would be best for the task at hand.

Decoupage Medium or Matte Medium: If you want a sealing layer over the top of a piece, use decoupage or matte medium. (These can also be used to adhere your papers initially, but I prefer not to deal with the stickiness of brushing the glue onto the backs of my images, since it invariably ends up in places I don't want it.) You may want to use one of these mediums to seal a piece that may be displayed without glass or to create a more polished-looking finish. They also work well for gluing together pages of an altered book to create added thickness for your collage work.

Paints

Acrylic Craft Paint: Although I have training as a painter and knowledge of professional-quality oils and acrylics, I find that simple, inexpensive acrylic craft paint is more than sufficient for my collages. It comes in a huge variety of colors. When you select a craft paint, pay attention to the opacity of certain colors and/or brands. Some tend to be more translucent than others, making it difficult to get good coverage.

Acrylic Glazes: Glazes are paints that add a tint of color yet allow what's underneath to show through. They can be used to tint part or all of an image or to make paper look aged. I prefer Golden Artist Colors glazes. (The glaze colors noted throughout the book all refer to the Golden Artist Colors products.)

Gesso: I begin much of my collage work by applying gesso to the surface. It gives paper extra weight and durability and also adds a nice tooth to the paper, making it easier to paint and glue on. When working in an altered book, you may want to gesso the pages to cover any words and create a blank slate.

Tools

Scissors: You'll need two pairs of scissors: a larger pair of standard craft scissors for cutting out basic shapes or large pieces of paper, and a small pair of detail scissors for more delicate work.

Craft Knife/Self-Healing Mat: Craft knives work well for cutting out small areas within a collage element, as well as for cutting thicker items like cardboard or mat board. A self-healing mat will protect the work surface while you cut.

Sandpaper: Sandpaper is great for distressing items. Rub sandpaper over photos or other collage elements to created an aged look.

Paintbrushes: I don't spend a lot on fancy paintbrushes; inexpensive craft brushes work just fine for the kind of painting I do on my collages. You'll need about four brushes to get started: a large utility brush for covering big surfaces, a ⅝" (16mm) brush for basic painting and two smaller detail brushes.

Bulldog Clips: Keep bulldog clips on hand to hold your art journals or altered books open while you work. There's nothing more frustrating than trying to work when your book keeps closing on you!

Writing Instruments

Pencil: A mechanical pencil with a fine point works well for adding detail or definition to collages without adding color.

Water-Soluble Pens: Fine-point water-soluble pens add more colorful details or journaling. I always opt for water-soluble pens because if I make a mistake, I can "erase" it with a wet paper towel, as long as it was written on a nonporous surface, like paint.

Water-Soluble Crayons: Water-soluble crayons will write on most surfaces. You can draw with them and leave your work as is or wet the marks with a paintbrush to blend the colors. As with water-soluble pens, you can also "erase" any mistakes.

Gel Pens: Gel pens are great for journaling or outlining items. I especially like white gel pens for adding detail to my work.

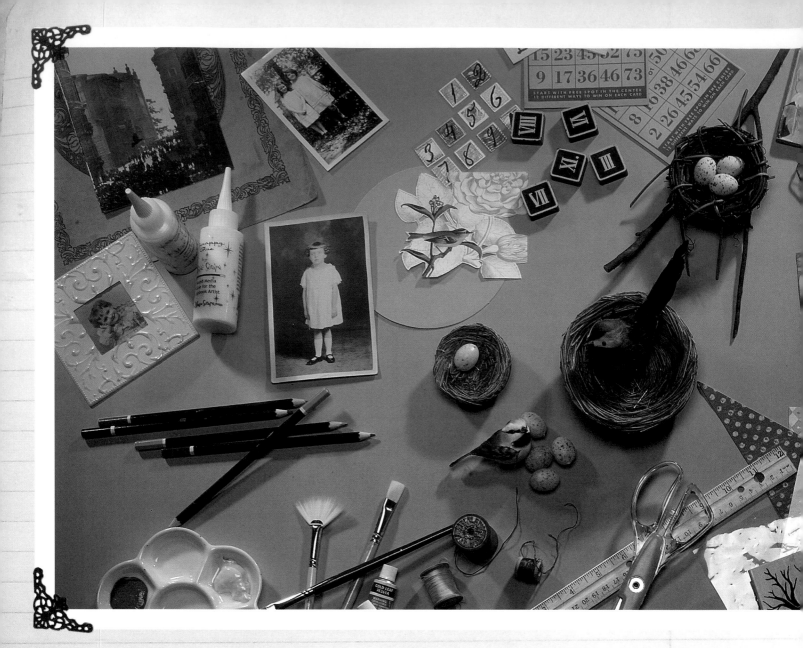

Substrates

Paper: A variety of papers are available for use in your collage. Consider using printed paper, such as old sheet music, and allowing some of the printing to show through to add character. If you're going to be using a lot of paint or wet glue, either gesso your paper or choose a thicker weight. Simple cardstock, watercolor paper or printmaking paper all offer good durable bases for your artwork.

Old Books: For my journals, I buy inexpensive used books. To create a sturdier work surface, I glue groups of four to six pages together with matte medium. I then gesso each spread. When I'm done, the book is ready to fill and already has an appealing messy, distressed look to it.

Matboard, Cardboard or Foamcore: These can be used when you need a heavier-duty substrate for your piece. Each has a different sort of surface that may lend itself to some styles of collage but not others. Matboard and foamcore both come in acid-free versions if you're concerned about the longevity of your piece. You can help cut down on the acid of any material by gessoing the surface, but this is not foolproof and should not be used as a substitute for an acid-free material.

Wood: Use blocks of wood as a substrate when you want a chunkier or three-dimensional look to your piece. Because wood is porous, it can be difficult to glue small items directly onto its surface, so I like to glue down larger pieces of paper with a decoupage or matte medium first to create a background upon which to build the collage.

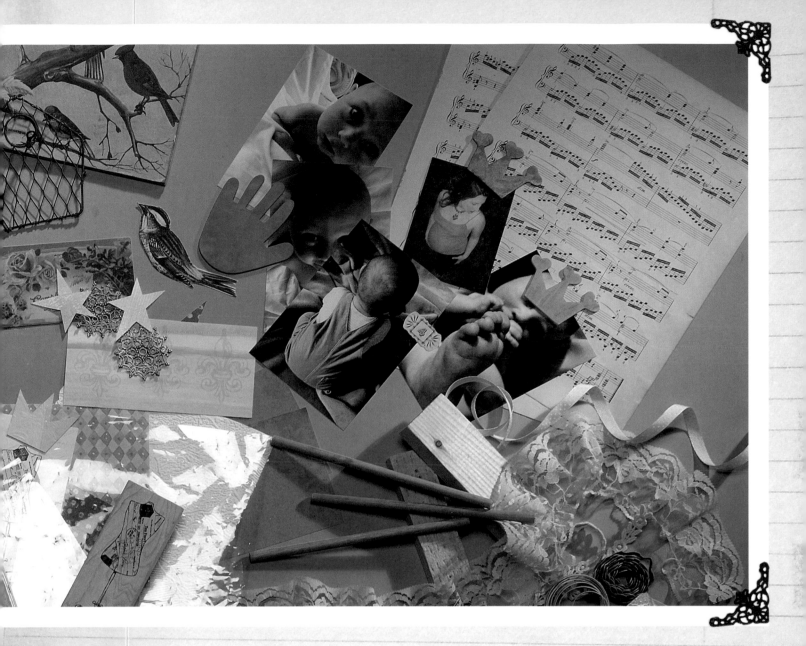

Ephemera

Modern Photos: These are perfect if you want to make personal, meaningful artwork. They can be used in any form—printed from the drugstore, your computer or on a photo printer.

Vintage Photos: Vintage photos can give a timeless, universal feel to your work. When you're doing personal artwork, you can use them to symbolize people and events in your life.

Scrapbooking Paper: There is so much great decorative scrapbook paper available these days. It is perfect for adding some pattern or color to your piece. Just be aware that if you use too much of it, you run the risk of your work looking like someone else's. I prefer patterns that look vintage and aged, and I usually don't use the papers as is. Instead, I paint or otherwise alter the paper until it loses its mass-produced look.

Wallpaper: Vintage or otherwise, wallpaper can also be used for the same purpose as scrapbooking paper. Because it isn't as readily available, it can give your piece a unique feel. When working with wallpaper, you may want to test a small area first because some wallpapers doesn't accept paint as well as other papers might.

Book Pages: I love old books, especially children's books. They have nicely aged paper and often use language and illustrations with a wonderful timelessness about them. (Be careful not to cut up a valuable or collectible book, though!)

Various Embellishments: Fabric, trim, bits of metal, mica, game pieces, flash cards, old jewelry—the list is endless and ever-expanding. I am always combing antique shops and eBay for unique items that may work in a collage.

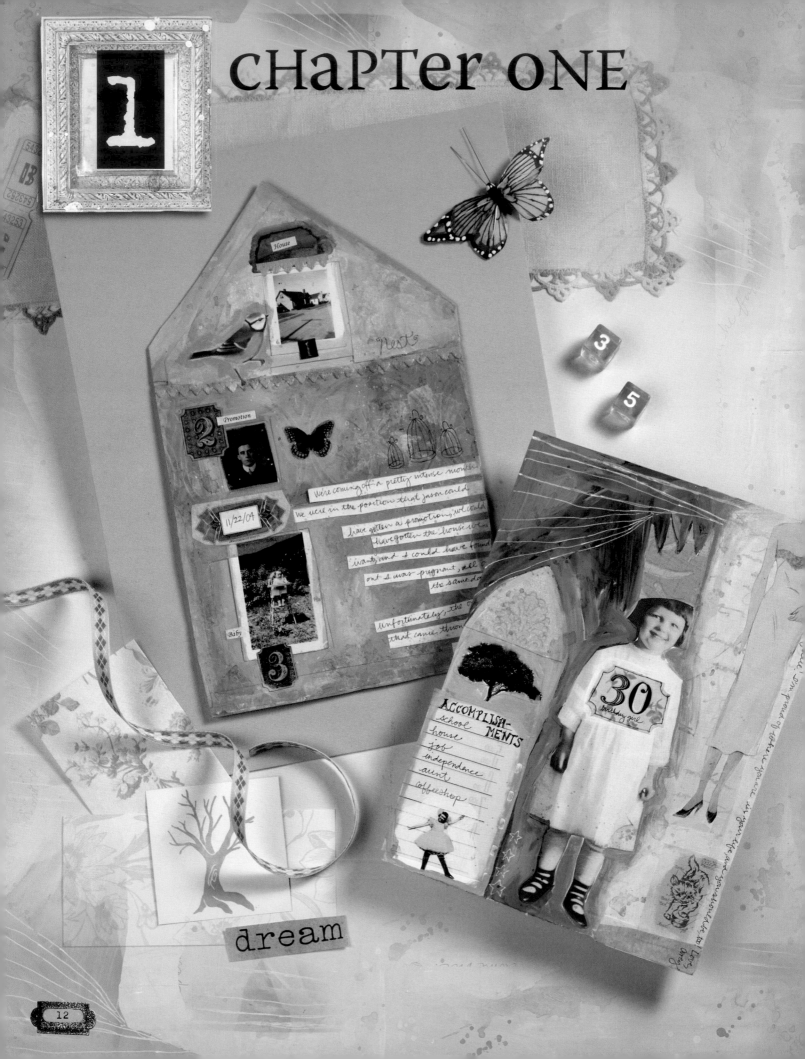

CHAPTER ONE

techniques for creating
collage with depth

My collage artwork has evolved over the years, just as all artists' styles constantly change. Look back at your own artwork and I'm sure you'll see major improvements, even if you're a beginning collage artist. When I first began creating this type of artwork, my style was simpler and more controlled than it is today. Through experimentation, trial and error, and sometimes simple luck, I've slowly developed a style that has much more depth and spontaneity. The deep, soulful mood of my work comes not only from the personal imagery I use, but also from the layers and rawness of my working process. Many of the techniques I use to create this look are quite simple, and I'll share them with you in this chapter.

Regardless of which techniques you use in your collage, the *way* in which you work can be immensely important. One of the most important things I've learned over the years is not to think too much about what I'm doing while I'm creating. I used to be very meticulous about my work. I'd lay everything out, and I'd rarely glue anything down until I was close to finished, worried I wouldn't like something once it was affixed. I avoided paint, because it seemed so permanent: What if I didn't like the results? But working in this way, I wasn't getting that messy, spontaneous look I wanted. So slowly I began to let go. Bit by bit, I began gluing things down earlier, even if I wasn't sure of their placement. I began adding paint to backgrounds. Essentially, I stopped worrying so much about the results and resisted the urge to "plan" my work. And, lo and behold, I started liking the results.

You should see me work now! I glue things down left and right and slap paint on almost everything. And if I make a so-called mistake, big deal! Nothing can't be changed. I'm not afraid of pulling things up that have been glued down (glue stick is fairly forgiving if it hasn't dried completely), or of painting or gluing images over things I don't like. In fact, during the beginning stages of my work, I hardly even think about what I'm putting down other than my focal images, because I know that most of my initial elements can be covered up. You are adding to the rich, layered look of your work every time you make one of these alterations.

Withered and Faded (below) is a good example. If you look closely, you can see how much is going on. There are decorative papers and images in the background that have layers of paint over them and then more papers over the paint. I added most of these layers while I was experimenting with colors, patterns and composition, painting or gluing over things I didn't like. But I allowed bits and pieces to show through, resulting in a piece that has lots of depth.

In this chapter, you'll learn how to achieve this effect in your artwork, but you'll also learn that letting go and giving yourself up to the process is the first important step toward making your art more personal, more uniquely you.

Withered and Faded

Letting Your Art Guide You

Another important lesson I've learned is this: It's OK to hate a piece of art. In fact, I'll go out on a limb and say it can be good to hate a piece of art. But hating your art isn't the difficult part; resisting the urge to just give up is what's difficult. When I get to the point when I'm ready to throw the art in the trash, that's when the good stuff happens. I know that if I can push through that urge, I'm on the verge of a breakthrough. And you know why? Because I hate the piece so much at that point that I don't care what happens to it, so I can let go of my control and just do what comes naturally. It's always at this point that I'm able to make a drastic change to the piece and ultimately turn it around.

For example, when I began this spread I titled *Newborn* (below), I was inspired by a vintage photo of a mother and a baby. I created a lovely design featuring a modern photo as a focal point on the left page and a crib image on the right page, but for the life of me, I just could not work that vintage photo into my design. I tried placing it below the crib, framing it in different ways, using different patterned paper around it, trying various paint colors, but it just wasn't working. It competed too much with the modern photo on the left page, and it was driving me crazy! Finally, in a fit of frustration, I ripped off the vintage photo and decided, "Forget it! I'm not using it!" Even though it had been one of the inspirations for the page, I ultimately abandoned it altogether in favor of simple words and embellishments that helped balance the spread. Had I not embraced the "hating it" stage and worked through it, I wouldn't have reached this end and probably would have disliked the work every time I saw it. It is now one of my favorite spreads in this journal.

For me, a big part of making my art my own is my process of altering most of my collage ephemera. I use a lot of storebought patterned paper and other preprinted items, but I find that usually, if used as is, they just look out of place in my work. They seem to stand out from their surroundings by looking new or mass produced. Even when I'm using vintage items, they often have too much contrast to them (black writing on white paper, for instance) for the look I want.

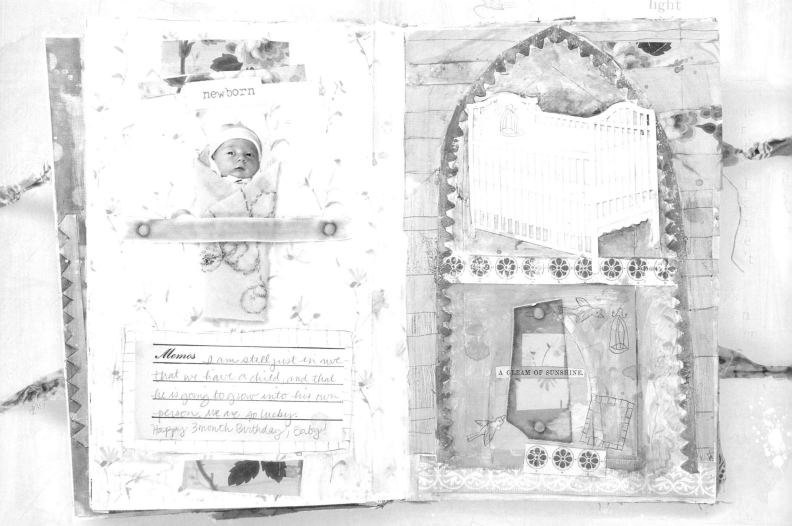

newborn

Memos I am still just in awe that we have a child, and that he is going to grow into his own person. We are so lucky. Happy 3 month Birthday, Baby!

A GLEAM OF SUNSHINE.

In creating *Resolute* (at left), I've altered much of my ephemera. You may not be able to tell, but I used various pink- and purple-toned scrapbooking papers around the edges of this piece. While I liked the color palette of the papers, I didn't like the amount of contrast they had in the designs, so I painted over them with similar colors, blending the look while allowing some of the pattern to show through. This subdued the contrast and created a more artistic look. I also altered the illustration of the settee toward the top. I cut this image from a clip-art book, but I felt the black ink on white paper was a little too strong—so I covered the piece with some tissue paper to soften it a bit. (A layer of yellow glaze or similarly colored paint would have created a similar effect.)

Throughout this book you'll notice me applying similar techniques to other pieces, using paints and glazes to tone them down. In much of my art, virtually every surface has paint on it. In addition to toning down patterns and high-contrast areas, painting or glazing also gives the piece a nice cohesive, aged look. I guarantee that if you have a piece that seems too disconnected, a thin layer of off-white paint or glaze painted over the entire piece will help unify it. Again, the more layers you're applying to the piece, whether with paint or paper items, the more depth it will have. And anyway, who wants to see that same patterned paper everyone else has on their art? When it's altered in some respect, it becomes unique to you, and that is the whole point of this book.

Following, you'll find a list of some techniques I use, as well as a step-by-step description of my layering process. Try these techniques, and try letting go a bit while you're working, allowing your subconscious to guide you. I promise you'll be rewarded with a richer, more spontaneous look to your art. We all want our work to have a look that is our own. By working more spontaneously and not being afraid to alter your materials, you should have a much easier time creating art that is uniquely yours.

Resolute

LaYeRinG PainT

You can achieve depth in your piece simply by layering several colors of paint.

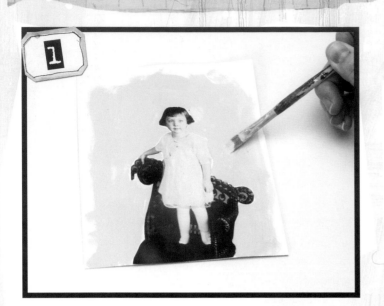

Apply paint

Apply a simple layer of one color of acrylic paint to the surface of your collage, painting around or over elements as you choose. Allow to dry.

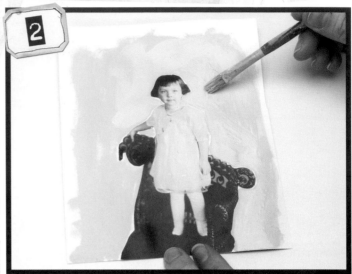

Layer paint

Brush another color of paint on top of the first. Experiment by applying the paint in thick and thin layers, allowing the bottom layer to show through in certain areas, such as around the outline of the subject.

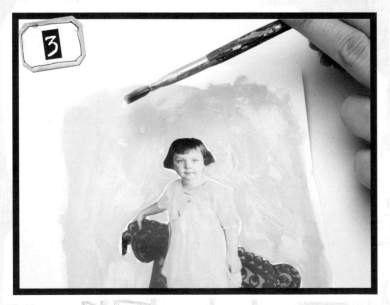

Splatter with water (Optional)

Use a slightly larger brush that will hold more liquid, and load it with water. Hold the brush firmly over the piece and tap it with your fingers so that drops of water splash onto the surface of the collage. (See Splattering Paint on page 18 for more on this technique.)

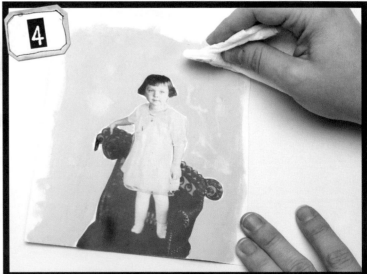

Blot with paper towel (Optional)

Wait until the top layer of paint has dried (usually a couple of minutes, depending on the paint). Then carefully blot the areas where the water splashed with a paper towel. The bottom layer of paint will be revealed in these spots.

Tip

I like using gray in layering paint because it can create a chalky effect when combined with other colors. Here are two examples of this technique, one (below left) with gray used as the top layer of paint, and the other (below right) with gray used as the bottom layer.

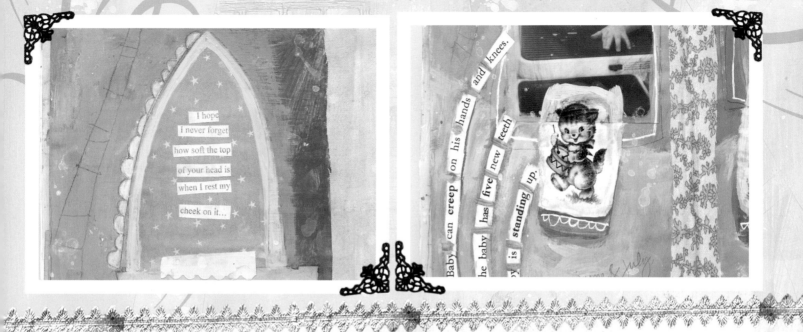

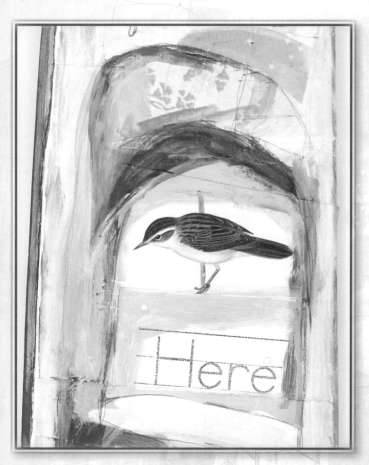

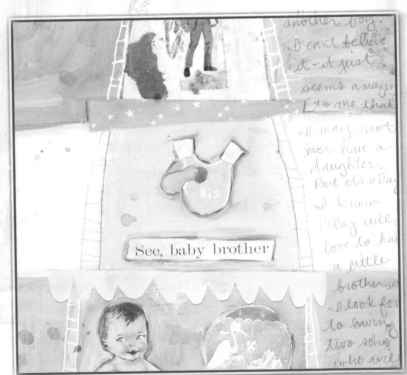

Looking up close at this portion of a collage I created, you can see several paint layers—blues, greens, browns and whites.

I had a hard time deciding on background colors for this page, so I tried a few different options. Looking up close at this portion of the collage, you can see blue coming through the yellow, aqua coming through the white, and peach coming through the blue, all working together to achieve a richer look.

sPLaTTeRinG PainT

Splattering draws everything together with a uniform finish over all the collage elements while adding an aged look to the piece. You can utilize splatters of paint in any color, though I most often use white or brown.

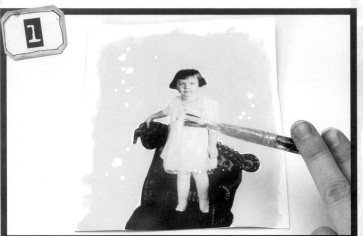

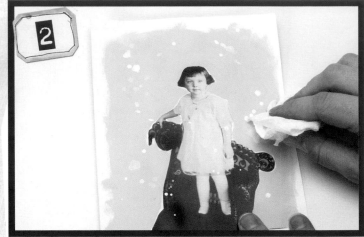

Splatter paint

Start by watering down white acrylic paint. The amount of water you use depends on how much pigment you would like in your splatters. Experiment until you reach a consistency that gives you the look you want. Use a slightly larger brush (so it can hold more liquid) and load it with the thinned paint. Hold it firmly over the piece and tap it with your fingers so drops of paint splash onto the surface of your collage. Don't worry about getting splatters on the images, but do try to avoid face images if the subject is a person.

Blot splatters

If your splatters seem too bright, let them dry for a few minutes and then blot some or all of them gently with a paper towel. This creates a muted, aged effect. Here you can see how I've picked up some of the white splatters and left others to dry as they were.

 Tip

Be careful when you're working with porous papers. Old paper tends to be dry and soak up paint quickly. When working with old or porous papers, either water down your paint more than you might otherwise or blot the paint without allowing much drying time.

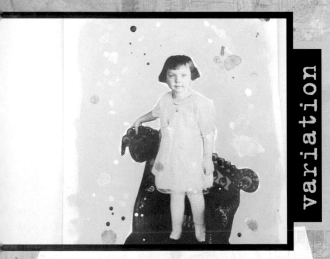

variation

Aging with splatters

Splatters of brown acrylic paint are another way to achieve an aged look. Here I used the same splattering technique as above, leaving some splatters to dry and blotting others with a paper towel.

The piece shown in detail here has a fairly plain background, so the splattered brown paint really makes a difference in giving it an aged quality.

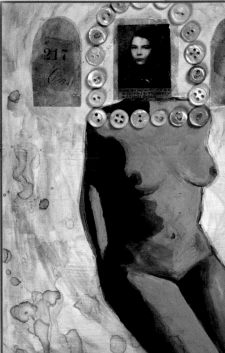

GLaZinG

Glaze comes in many colors and can be used to make your artwork look aged or, conversely, to add a tint of color to elements that are too dreary.

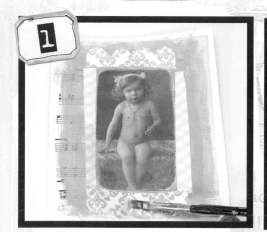

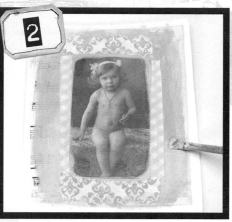

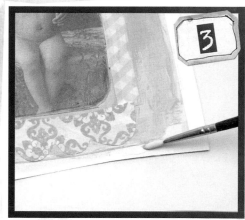

Begin applying glaze

Select an element in your collage that is too bright and brush some Fresco Cream glaze over it. Here, the decorative papers I've chosen are too bright to match the antique image, so I applied the Fresco Cream glaze to bring an antique look to the papers. If you want to create an even more worn-looking effect, opt for Yellow Ochre glaze.

Finish applying glaze

Look for other areas you would like to tone down, and apply the Fresco Cream glaze to them, as well. Here, once the papers had been aged, the pink paint looked a bit too bright, so I brushed the glaze over it to mute the color.

Apply accent colors

Now look for areas that could use hints of color or brightening, and apply a more colorful glaze to those areas. Here, I applied Aquamarine glaze to the border to add a bit of color, while still allowing the pattern of the sheet music I used as a background to show through.

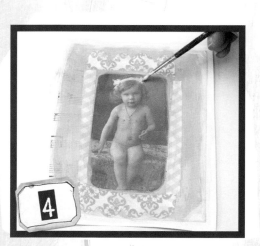

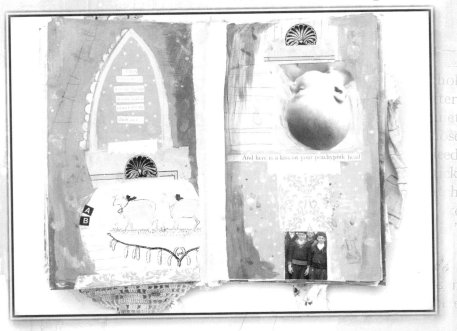

Colorize areas

If you are working with a black-and-white or sepia image, find an area you would like to colorize. Here, I colorized the bow in the image using the Aquamarine glaze.

For this spread, I've applied Fresco Cream glaze over the vintage book page with the lamb illustrations and also over the decorative damask-patterned papers. Both backgrounds were a little too bright for my taste, and glazing them toned them down nicely.

Tip

If your collage elements still don't look tinted enough once you've brushed them with glaze, apply a second coat. You can also experiment with layering different colors of glaze until you achieve the desired look.

LAYERING PAPER

Rather than building your collage on a plain piece of paper, you can combine papers with different textures and patterns to create a more interesting background.

Adhere paper scraps to base

Begin by adhering scraps of paper to a plain collage surface. As you work, overlap papers to create seams, which will add to the depth of your piece later on. I often begin with handwritten pages or ledger pages and then introduce colored papers to establish a color scheme for the piece.

Paint over layered papers

Brush watered-down acrylic paint over the piece, allowing the textures and patterns from the papers to show through. Now you've established some depth on your page before you've even begun, and you can start building your collage from here.

Tip

In addition to using paper with different textures and patterns to add dimension to your background, try using pieces of embossed paper. By painting them, you can create an interesting tactile base for your collage.

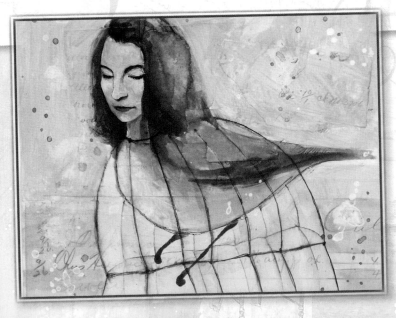

In this portion of one of my collages (below), I used many pieces of paper in the background and painted over them in various colors. Notice the faint images of trees toward the bottom. I painted over them until only a shadow of the images remained.

Here you can see subtle traces of handwriting showing through on this piece from the ledger pages I layered as a basis for my painting.

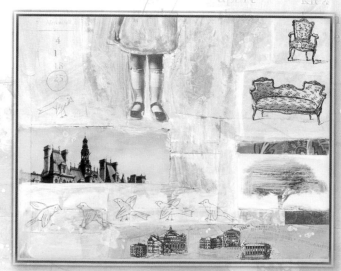

GOING BEYOND THE PAGE

You don't have to limit yourself to the piece of paper you've started working on. If you let your creative muse take over, you might find yourself adding things beyond the boundaries of the page.

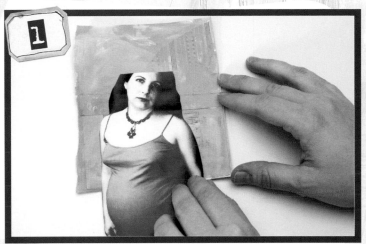

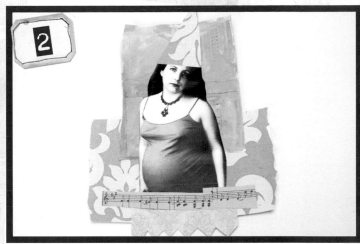

Add focal subject

Select a background for your collage. Here I am going to begin with the background I just created on page 20. Add your focal subject or image anywhere you choose. Don't limit yourself within the boundaries of the page.

Add collage elements

Continue adding collage elements—either on the page or beyond it—until you've established a composition that feels balanced and interesting to you. From there, you can add other collage elements and more detail.

Tip

Pieces created "beyond the page" look especially good framed "floating" on matboard behind the glass of the frame. To display this collage, I placed a layer of foamboard between the piece and the background mat to add dimension and accent the irregular edges.

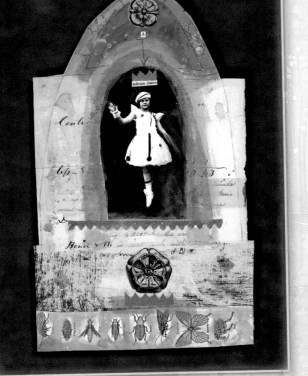

This piece, *Solemn Dance*, began with the image of the dancing girl, and expanded out from there to create a more unique shape.

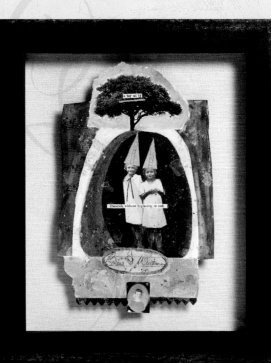

CREATING TISSUE OVERLAYS

I love using different layers in my work. Tissue paper is great for this because it allows elements from underneath to show through. You can buy mass-marketed printed tissue paper, but I like to create my own with images of my choosing.

Create master copy

Create an 8½" × 11" (22cm × 28cm) master copy of the image or images you want to transfer to tissue paper. Here I cut out several images I liked from a clip-art book, glued them onto a sheet of text-weight paper and made a photocopy.

Prepare tissue paper for copying

Use a glue stick to adhere a piece of tissue paper onto a plain white piece of 8½" × 11" (22cm × 28cm) text-weight paper. Apply a very thin line of glue around the edges. You want just enough glue to adhere the two pages together so they can run through a photocopier without jamming, but you don't want any of the images on the tissue paper to be glued to the regular paper underneath.

Copy images onto tissue paper

Use a photocopier on the manual feed setting to copy the images from your master copy onto the tissue paper. You can then either cut around the edges to detach the tissue overlay, or leave them attached for sturdiness in storing the page. Cut out any images you want to use.

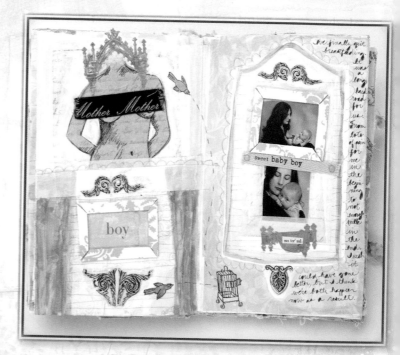

On this piece, I used tissue overlays of decorative scrollwork to add a touch of elegance.

Adhere embellishments

Use a glue stick to adhere the overlay to a project.

mY StEP-bY-stEP LaYeriNG ProCEss

Over the years, I have developed a loose step-by-step process for building a collage with a rich, layered look. I certainly don't follow all these steps for every single project, but generally, most of my art seems to evolve this way. I may alter my process by skipping or repeating steps, but overall it remains the same.

Choose images

Select the image (or images) you want to feature as your main subject(s).

Adhere background papers

Start adhering scraps of paper around the image(s) using a glue stick. Keep in mind that much of this material will be covered up by other layers later.

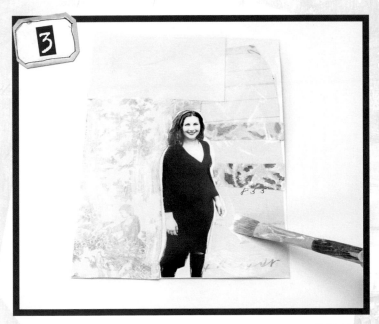

Apply paint

Apply your first layer of paint, covering most or all the papers you just applied. In this step, you could use one or several colors to begin building your composition. As you work around your focal image(s), don't worry if the paint overlaps a bit—this will add to the layered look.

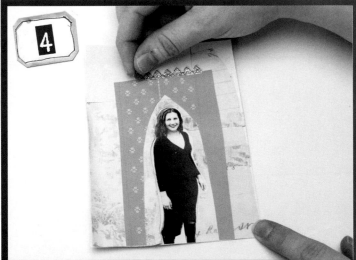

Add embellishments

Add another layer of paper and/or embellishments. At this stage, start working toward what you want the final piece to look like. The elements you add here can still be covered later if you desire, or they may be left as part of the main composition.

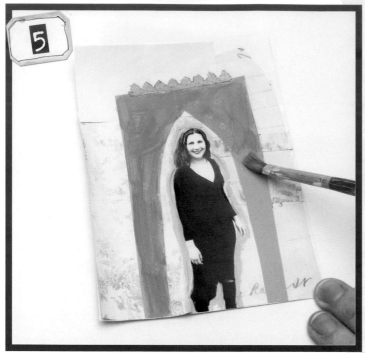

Layer paint

Add paint to the top layer of collage elements and to areas needing more texture or color. Here, I used thin brush strokes of olive-green acrylic paint to tone down the pattern in the top layer of paper. I then painted over the German foil paper with a burnt-orange color to alter it a bit, and added a lighter green to the area outlining the focal image.

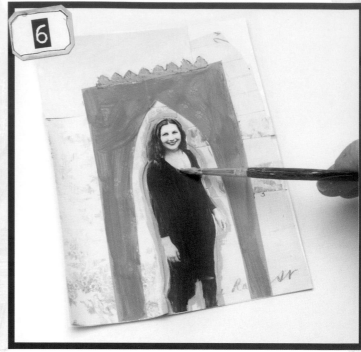

Apply glaze

Add glazes to areas that need tinting. I applied Fresco Cream glaze to the black-and-white image to warm it up and make it look less stark against the surrounding elements.

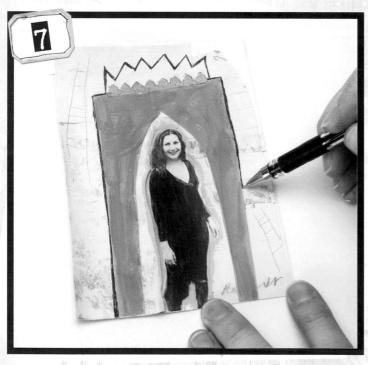

Add pen and pencil details

Draw sketches or lines with pen and pencil to add more detail to the piece. My favorite pens are the Pilot Hi-Tec-C and Uni-Ball Signo because they write easily on painted surfaces, come in a wide variety of colors and are water-soluble.

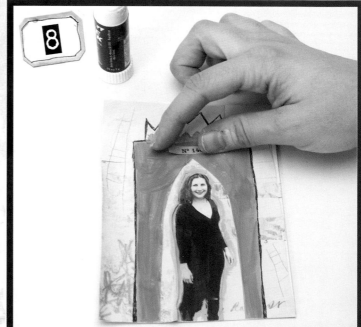

Add additional details

If you feel anything is missing, add final touches. I often use water-soluble crayons to add splashes of color. I also add any finishing collage elements (like the strip of numbers shown here) that I think enhance the piece. Finish by splattering the surface with watered-down paint, as described in detail on page 18.

August 25th, 2006

This pregnancy is so different from my first. While I am excited about a new member of the family, I most find myself scared to death that I won't be able to handle two at a time.

month 4

Mother

This piece, *Mother*, was created with my layering process. You can see the focal image of a pregnant me; old sheet music in the background covered with multiple layers of green, lavender, gray and black paint; additional collage elements; pen, pencil and crayon details, including the birds and birdcage drawing and the outline around the focal image; blue crayon scribbles and journaling; and white splatters.

CHAPTER two
modern photos
in collage

One of the best ways to make your artwork more personal is to use current, personal photos. Images of yourself or your loved ones instantly transform a piece of art into an intimate, personal story and take your work a step beyond the cliché of most collage artwork. When I look back on my own work, I'm especially drawn to the pieces featuring my own image or a photo of a loved one. Why? Because they tell such a story. Think about what appeals to you in other people's artwork. Chances are, you are attracted to those in which you can see a glimpse into the artist's life. Personal images can transport you to another time and place, they can show you an artist's personality and, most important, they can evoke great emotion.

I know a lot of you are saying, "Oh, but I hate photos of myself," or, "Modern photos just don't fit with my style of art." Believe me, I used to feel the same way. I struggled with incorporating current images into my artwork when I began. They always ended up looking so contrived and out of place. I was at a complete loss the first few times I tried using them. But my desire to document my life forced me to develop ways around these difficulties. I now have many methods of working with modern photos to meld them almost seamlessly with my style. In this chapter, I will share these techniques and show you how to create your own beautiful collages with personal, modern photos.

I generally work with two different types of photos. The first, "photo-shoot photos," consists of universally themed photos I take for the express purpose of using in my artwork. The second, snapshots, consists of photos that have been taken in the normal course of life, typically to document special events or memories. Both styles of photos can be very meaningful, effective elements of your artwork.

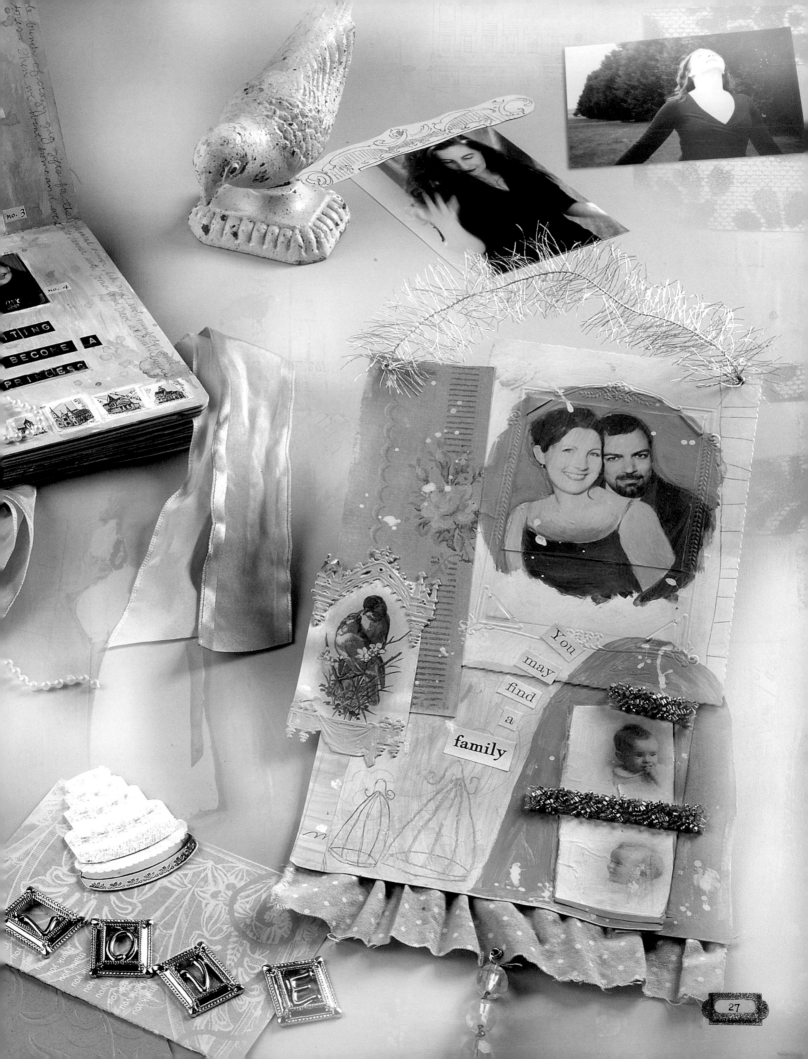

You

may

find

a

family

Photo-Shoot Photos

I like to stage artistic "photo-shoot" sessions to capture images of both my loved ones and myself. My intention with these sessions is to generate lots of stock images for use in my artwork, but as an extra bonus, I often end up loving these photos much more than snapshots or professional portraits. Because the photos have no purpose other than to capture the subject's personality, they have a more honest, less contrived quality than many other photos do. There's no, "Okay, everyone! Smile for the camera!" The shots are not forced; they simply allow the subject's personality to show through naturally.

When I stage a photo shoot, I don't have specific pieces of art in mind for the shots. I just try to get as many photos as possible. Then, any time I'm starting a new piece, I can just look through my files and select a good match for the theme I'm trying to portray.

I've found that photo-shoot photos are universally helpful in my work for a number of reasons. First of all, they aren't documenting any specific event or theme other than the person being photographed. At the same time, they are far less formal than portraits. Since I stage my photo shoots in neutral colors (or even in black and white or sepia) and make an effort to exclude extraneous background elements that might be distracting, the resulting photos tend to have a timeless look to them. And while the shoots usually yield handfuls of photos that you might be tempted to set aside as "bad"—blurry images or images of only part of the subject,

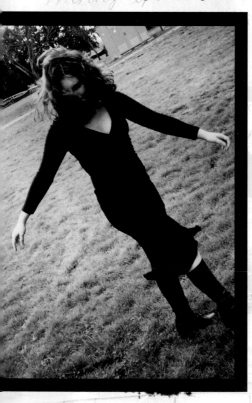

for example—even those shots often lend themselves to inclusion in a piece of art when you least expect it.

Take a look at some of my own photo-shoot photos, shown on this spread. All of them show some aspect of my personality and character. This infusion of mood and life makes these photos ideal for use in artwork.

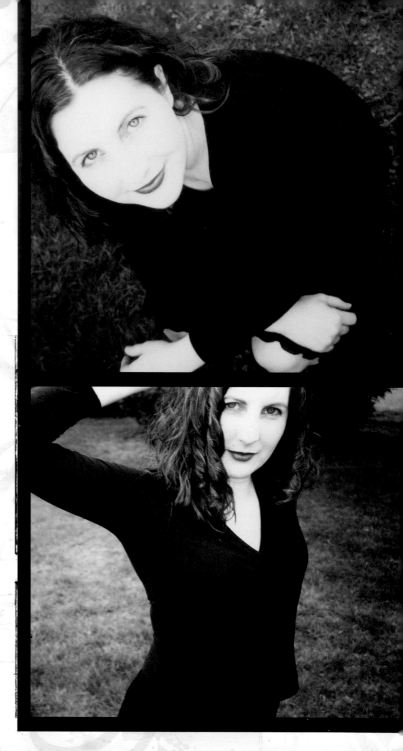

Here are some tips for staging a photo shoot that will yield the best results for your artwork. Keep in mind that these aren't technical suggestions from a photographer's standpoint (it has been years since I took a photography class!) but simply tried-and-true compositional tips from an artist's point of view.

Tips for Setting up a Photo Shoot

⌗ For photos of yourself, find a friend to serve as your photographer. If you can't recruit a willing volunteer, set your camera up on a timer. For photos of a friend or loved one, try being the photographer so you can control the results.

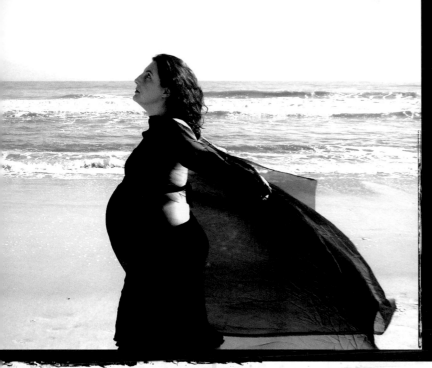

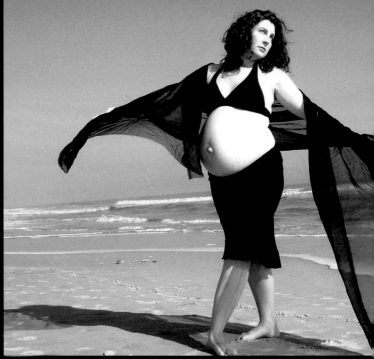

- Familiarize yourself with your camera settings. If your camera has multiple shutter speeds, set it to take photos quickly without having to pause between shots. The less the subject has to stop between "poses," the more movement and flow will be reflected in the resulting photos.

- If you are using film, decide whether you want color or black-and-white film. If you are trying to achieve a timeless look, black and white is probably your best bet. If you're shooting digitally, though, you can have the best of both worlds, shooting in color and then using photo editing software to convert the photos to black and white or sepia as you wish.

- Find a location where you won't need a flash, such as outdoors or near a window with lots of ambient light. (Flashes can create harsh lighting that will make your images look less natural.)

- Select a backdrop or setting that's as neutral as possible. Experiment with trees, grass, a plain-colored sheet hung on the wall or placed on the floor—the less extraneous stuff, the better. A simple color palette is easiest to work with when you're incorporating a photo in your collage.

- I also recommend neutral colors for clothing. I favor black because it shows up nicely in black-and-white photos and defines the subject's form with a fluid line. Regardless of the color, though, choose a style that's timeless. If you are photographing a baby or small child—or if you're brave enough yourself—nude photos are the ultimate in natural beauty.

- Consider incorporating some basic, neutral props, avoiding anything specific that might later date the photo. You might try a simple chair, a pretty flower or a flowing piece of cloth (as shown above).

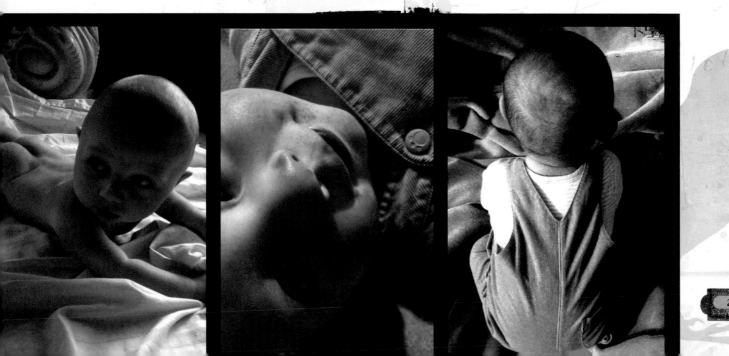

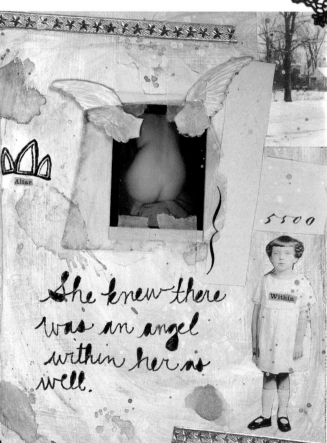

Altar

Within

5500

She knew there
was an angel
within her as
well.

Tip

Try using a Polaroid camera for nude photos if you don't have a digital camera—this way there's no embarrassment when you pick them up! I have a Polaroid i-Zone (I don't think this model is available in stores anymore, but you might find it on eBay) that takes wonderful tiny photos like the one used in this piece (above). Since you can't even see my face in the photo, it's timeless and neutral to the viewer, yet it's personal to me.

Tips for Photographing Your Subject

⌗ If your subject is a kid, you're in luck: Kids find this fun. Adults will probably feel somewhat silly during this exercise, but encourage your subject (or yourself) to try to be as uninhibited as possible. The best photos seem to come from moving around. Twirl, look at the sky, sway back and forth, touch the ground, lean forward, lean backward, reach your arms up, turn your face away, let your hair fall in front of your face … you get the picture. You may feel self-conscious during the shoot, but I guarantee the results will be worth it. Try to avoid looking at the camera too much, and the same goes for smiling. Some smiles and straight-on shots are fine, but you just don't want it to look as if you're having a portrait done. These shots should be free and natural and spontaneous.

⌗ If you're the photographer, experiment with lots of different angles—get on the ground and shoot up, stand on a chair and shoot down, move close, move far away, take some shots of just body parts, take some of just the head and face, tilt the camera at an angle, and snap some shots straight-on. Don't wait for the perfect shot; just shoot and shoot and shoot.

After the Shoot

Once you're finished with the shoot, it's time to look at your results. Sometimes the shots you thought you had botched end up being among your favorites. If your photos are digital, experiment with photo editing software to make some creative adjustments. Play with the colors and cropping to make yourself an even wider selection of photos to choose from. I usually make my color and cropping adjustments all at one time, and then print the photos in various sizes so I have a wide variety of options on hand when I'm ready to do a piece of art. Sure, I end up with more images than I need, but it helps me to be more spontaneous with my artwork since I don't have to go print out photos in the middle of a project. (Of course, if you can't find a photo that works for what you're creating, you can always make some additional adjustments on the spot.)

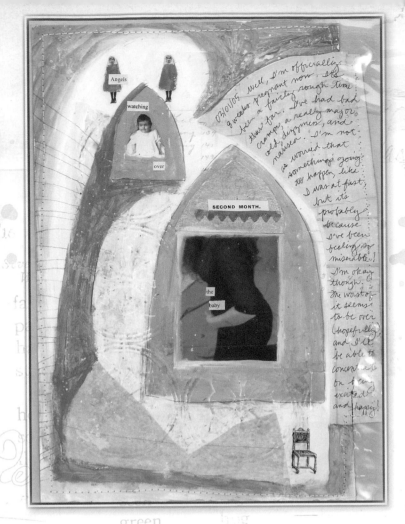

Angels Watching

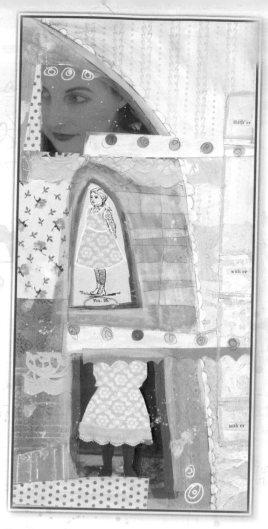

Thither, Whither, Nether

Try not to be too critical of your photos. Remember, they don't need to be perfect. In fact, it may be preferable that they aren't perfect. It's surprising how well imperfect ones can blend into artwork. For example, *Angels Watching* (above left) uses a photo that is far from what I'd consider a perfect photographic specimen. My face isn't showing, the image is slightly blurry and the pose is sort of unusual. However, when I went to create this piece of art, this particular photo was ideal. It's a piece done shortly after finding out I was pregnant for the first time. I was paranoid that something would happen to the baby, so I did this piece about angels watching over him. The photo-shoot photo I used shows me holding my hand on my stomach and turning away from the camera. Oddly enough, when the photo was taken, I didn't even know I was pregnant, so I hadn't posed that way purposely. I think the pose fits the mood I was trying to express perfectly—contemplative and turned inward, focusing on the baby. This is a photo I initially disliked, but I'm so glad I hadn't thrown it away.

Photo-shoot photos can also have universal appeal. Even if the resulting artwork is made to tell your own story, using your own image, it may also speak to others because of the nonspecific nature of the images. The photos that often result

from these shoots can be representative of anybody, even though you might initially perceive them as more personal.

Thither, Whither, Nether (above right) is a perfect example of a universal piece of art that uses my personal image. Obviously, the image is of me—there's no question about it. However, because I didn't include any extra background in the photo and printed it in neutral colors, it could also be perceived as a very generic image of a female. It's neutral and could represent just about anyone. The other imagery in the artwork is also very personal to me, but again, it's not so specific that it couldn't have meaning for someone else as well.

You'd be amazed how far the photos from just one good photo shoot can take your artwork. As long as your shoot yields lots of varied and interesting results—particularly if you can alter them digitally—one shoot can fuel years' worth of self-expressive artwork if you're creative in the way you use the photos. Younger subjects, especially babies and small children, are the exception. Since they grow so fast, you'll want to do photo shoots far more often.

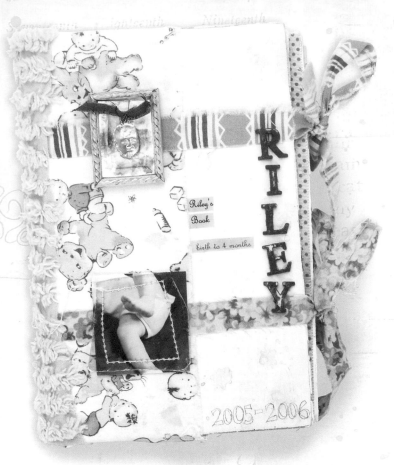

One of my first photo shoots with my newborn son proved to be quite prolific. (Some of these photos are on page 30.) This page shows two pieces in which I've used photos from this shoot. One is a spread in his first baby journal (below) and the other is the journal's cover (at left). The photos used in these pieces don't document anything specific, so they are perfect for the purposes of these works. As you can see, a couple of the photos are virtually the same image. In fact, I'm sure I have used these exact images in other pieces, as well. They are such universal baby photos that I'm sometimes still able to use them even now that he is older.

Even photo shoots done at specific stages of your life can sometimes prove to be more versatile than you originally anticipated. For instance, my husband shot a collection of photos of me when I was pregnant with Riley. I used several of them in pieces I created during that pregnancy, but now that I'm pregnant with my second son, I'm able to use them again. *Mother* (see page 25) was done when I was in my fourth month of pregnancy the second time around. Although the photo depicts me much further along, it's universal enough to be used to represent me at any point during my pregnancy.

Riley's First Bookcover (above); Sweet (below)

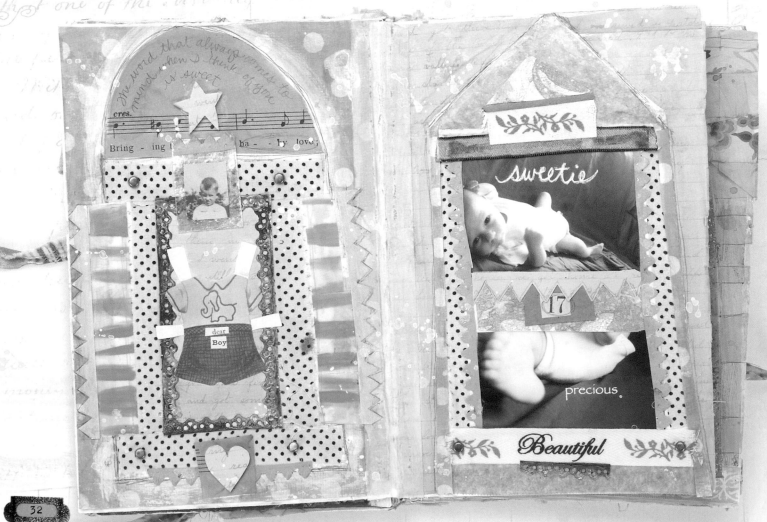

This is the beauty of photo-shoot photos. They are perfect photos to use when you are looking to capture the essence of a person or theme without documenting anything specific. When you do want to illustrate a more specific theme or event, you can dig into your stash of snapshots for the appropriate photo.

Snapshots

We all have ever-growing stashes of snapshots—photos shot in the normal course of life to document birthdays, vacations, milestones and anything else under the sun. Whereas photo-shoot photos are neutral and nonspecific, snapshots are just the opposite. They document memories.

While a photo-shoot photo is perfect to use on a piece about a more general theme, such as how much you admire your mother, it might not be adequate to use on a piece depicting a specific moment in time. For instance, a piece of art commemorating your baby's first steps would seem to be missing something if it didn't have a photo of your baby walking, wouldn't it?

I use snapshots most frequently in my son's baby journals. There's always a new milestone to commemorate, and what mother doesn't have tons of baby photos to sift through? If you are on the scrapbooking side of art making, most of the art you do illustrates your family's daily adventures, so you probably will find even more use for snapshots than a traditional collage artist might.

One example of this type of artwork is *3½ Months* (below), a spread about some milestones my son hit at about three and a half months of age: He had his first baby cereal and also learned to hold his toys in his hands. Being a new mother, I had of course taken photos of these moments, so when I decided to create the artwork, it was just a matter of choosing which photos best depicted these activities. I chose two pairs of photos and cropped in tightly on my son's face so the focus was on the activity he was doing. I also used photo editing software to mute the colors of the photos to give them a softer appearance. I created frames around the images and journaled a bit to complete the pages.

3½ Months

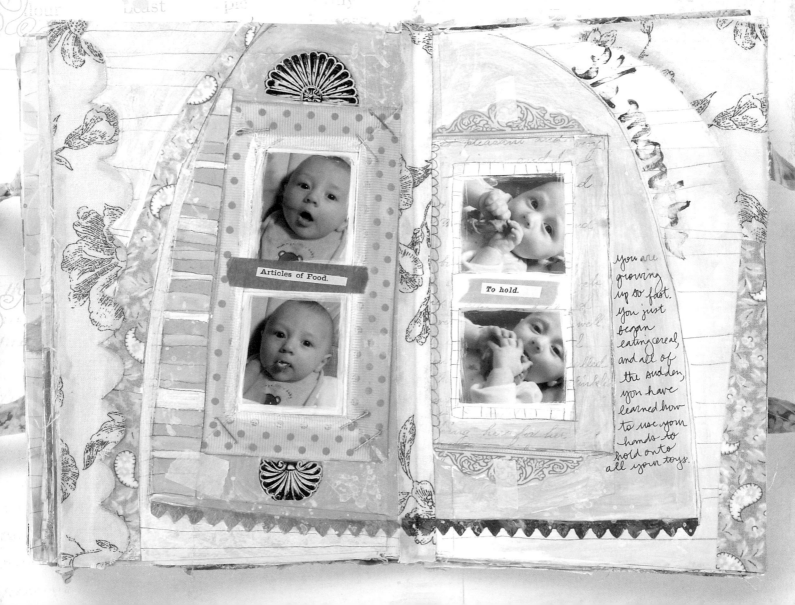

A second example, *The Baby Is into Everything* (below), is a similar spread depicting milestones he hit at eight to nine months of age. The piece focused on my son becoming mobile and beginning to get into everything, so I chose photos that were good illustrations of this. Even though specific snapshots of each milestone are not included, the collage still conveys the theme.

A final example of using snapshots in my artwork (at right) is one that came about in a sort of backward way compared to how I usually work in my son's book. Whereas normally I would have a theme in mind and then find a photo to fit, in this case, the artwork was inspired by the photo itself. When looking through photos of my son's first weeks, I noticed one particular shot that reminded me of one of my own baby photos. So I created this spread specifically about those two photos: snapshots from two different generations. The piece is about trying to decide who he will look like when he gets older. By the way, we still haven't figured that one out!

If you're creating artwork commemorating events from years ago, snapshots will be invaluable to you, since they are the only visuals you have from the past. Even if you don't have the scanning and photo editing equipment to alter them digitally, you can do quite a bit using just a simple color photocopy machine to adjust the size and appearance of the images. Often, though, old, worn photos have faded to lovely colors that work surprisingly well in artwork, even if the colors aren't true to life.

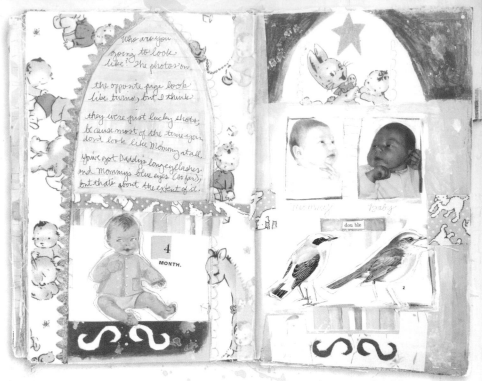

Double

The Baby Is into Everything

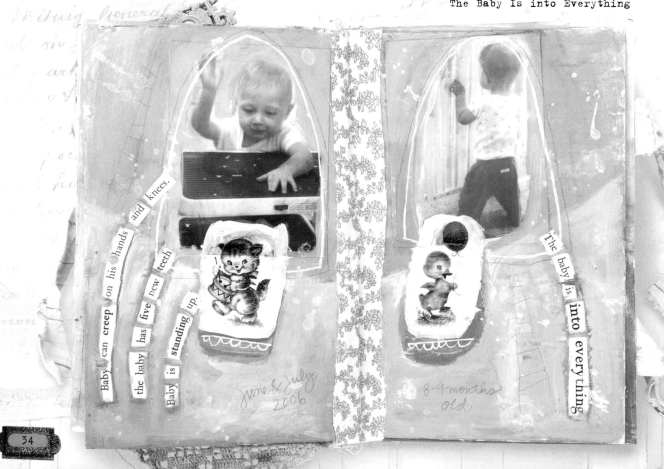

So, take a look in your photo stash the next time you're doing a piece of art. Maybe you have some photos that would work perfectly. Or, maybe this has gotten you thinking. You never did do a piece of art about your daughter graduating from high school, did you? Or about your grandson being born last year? It's never too late to go back and commemorate an event with a piece of art, and with snapshots, you already have what you need to get started. And in the future, you may begin thinking ahead when you're taking photos. Obviously, your first priority when taking photos of an event is to commemorate the situation for memory's sake. However, it doesn't hurt to think about the artwork you may want to do and make sure you get some good shots for that as well.

An Introduction to Modern Photos in Collage

You have now taken the first step toward moving your artwork in a more personal and meaningful direction. You've taken some photo-shoot photos, and you've begun to think about using snapshots in your work. How does it feel? A little scary? Are you still wondering how you're going to incorporate all these great photos into your art? That's okay. That is the next step in your path, and I'll help you along.

Artists often tell me they'd love to use photos of their own children or loved ones in their collages, but they are at a loss as to how to go about it. With this style of art, it's common to use vintage photos, but something newer than 1950? Forget it! New photos just don't seem to fit into a typical collage style.

Some of the first pieces I made with modern photos were those in my wedding journal. It took a lot of effort to think of ways to incorporate them because I was so used to using vintage photos and ephemera exclusively. The first spread in this book (at right) uses a black-and-white photo-booth strip of me. These photos were taken a few days before the wedding, while my sisters and I shopped for favors for the rehearsal dinner.

"Hey, wait a minute, Corey," you say. "A photo-booth strip? I use photo-booth strips all the time in my collages, only they're vintage ones." And this is exactly what I said to myself. What a perfect first step! Using a style of photo I'm used to working with made that jump a little easier because it felt more familiar to me than the other modern photos that had been stumping me. Try it yourself: Find a photo booth (if you don't know of one, search the Internet for Web sites listing locations of photo booths) and do a mini photo shoot

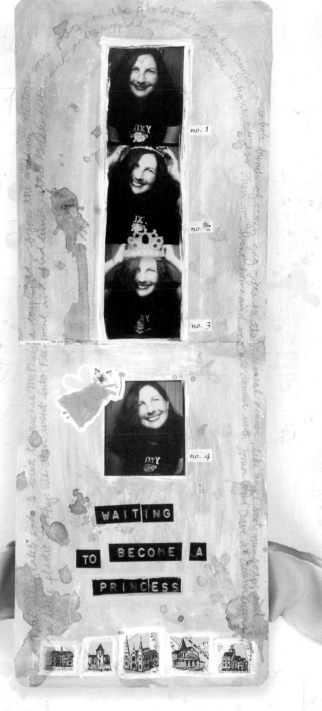

Waiting to Become a Princess

of yourself. Then, incorporate the strip into a collage the same way you would if you were working with a vintage one.

Soon I was using modern photos of all sorts in my artwork. It's easier than you might think! Start with your photo-shoot photos. Since they're more universal, they're already tailor-made to blend well with collage ephemera. Snapshots can be a little more difficult to incorporate into your work. These are often brightly colored photos with busy backgrounds, and they usually don't feel "timeless" at all. How in the world are you supposed to fit that into a collage?

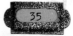

The trick is this. For any item that doesn't seem to work with standard collage fare, you need to blur the lines between that item and the rest of your artwork. Say you're working with a garishly colored snapshot. The goal is to make that photo look as though it belongs, through the use of paints, papers and other alterations. There's no rule that a photo has to be used "as is" in a piece of art. Paint on it, glue on it, cut it, distress it, do whatever needs to be done in order to minimize the contrast between it and the rest of the piece. For the *January 31st* spread (below) in my son's book, the photos have been sanded, painted, glued and colored—all to make them a more natural part of the work of art.

When you work with an unusual element such as a modern photo, make it the first item you place on your collage surface. This way, you can work the entire collage around it, rather than trying to fit it in at a later stage. As a result, the photo blends with the whole piece and is enhanced by all the other elements, rather than standing out as different. Beginning your collage with a photo will help you determine your color palette, as well. If you like the colors in the photo, you can pull them into the piece. Or, on the flip side, if you don't like the colors in the photo, you can help minimize their strength by pulling them into the piece. Your first instinct may be quite the opposite: For example, if

you hate the red shirt you're wearing in the photo, you may decide not to use any more red in the piece. However, doing so will only call attention to the red shirt. Instead, incorporate red elsewhere on your collage, and you'll hardly even notice the shirt in the final piece. This is especially handy if you feel the colors of the photo are too bright. Instead of using toned-down colors for the rest of the piece, pull some of those bright colors until the photo looks like it belongs in its surroundings. The goal is to make the piece look cohesive.

For example, in *One of These Birds* (opposite page), my printer was running out of ink and created a yellow-toned print. Instead of reprinting it, I decided to work with those colors. I used yellows and greens in the areas surrounding the photo and created a unified piece. Had I shied away from those colors, the unusual tones would have only stood out more.

Blending the photo into the art can be done any number of other ways. Following are some of my favorite techniques of blurring the line between a modern photo and the piece of art. You've already seen many of them in action in the artwork throughout this chapter, and now I'll teach them to you, step by step. These are by far not the only ways to work with modern photos in collage, but you can use these techniques to build and expand your skills.

January 31st

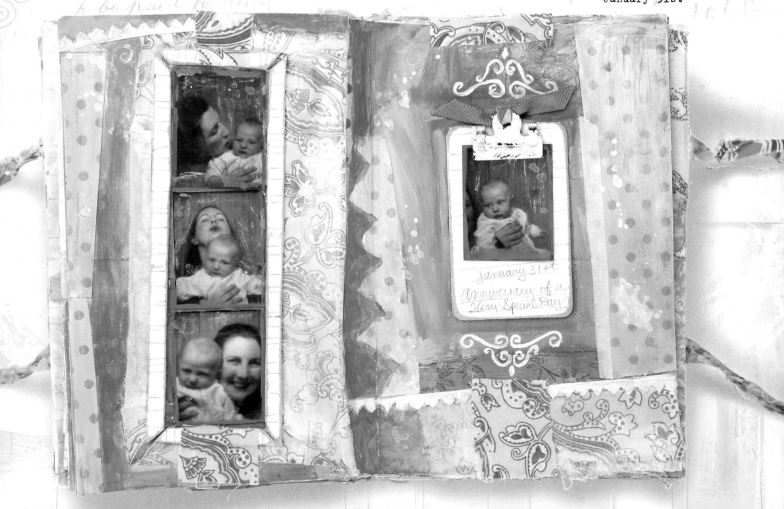

One of these birds

One of These Birds

tECHnIQues For workInG with MoDErn pHoTos

Covering a Photo's Background

One of the best ways to incorporate a modern photo into a collage is to eliminate all the extraneous elements in the photo's background. This simplifies the image so you can better incorporate it into the piece, and focuses attention on the subject of the image. There are two main ways to cover a photo's background: with paint or with collage elements, such as patterned paper. Here I used paint to cover the background of this photo to make it a more suitable collage element.

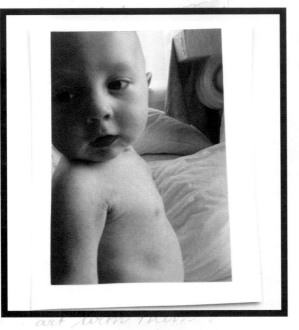 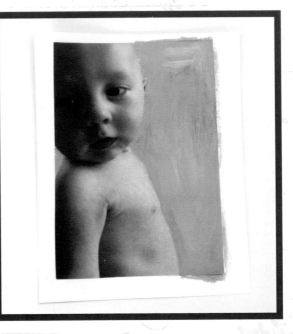

Here I used a variation of the same technique, this time adding patterned papers to cover the background so the image could be incorporated more naturally into a collage.

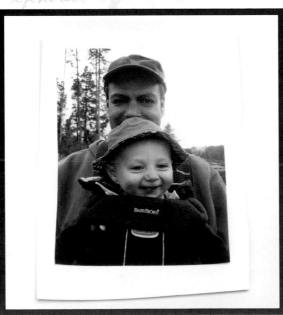 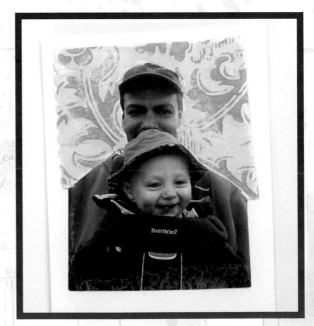

Converting an Image to Black and White

One of the simplest ways to incorporate a modern photo into a collage is to change the color palette of the photo. In this photo, the colors and print of my son's pajamas were distracting, so I used photo editing software to convert the image to a dark sepia and enhance the contrast. (If the photo you're working with is not digital, or if you don't have photo editing software, you can achieve a similar transformation with an ordinary photocopier.)

fa ther hood

DaDa

He's better than Mommy at making me laugh.

He taught me how to make a funny sound with my mouth.

He plays with the spiky ball with me.

He gave me long eyelashes that the girls are going to love!

He's going to teach me how to use tools someday.

Both of the photos featured in this collage, which I created for my husband's first Father's Day, were originally brightly colored, so I converted one to a sepia and the other to soft, muted tones. These subtle changes helped them blend with the colors in the piece for an overall cohesive feel.

Extending a Photo

Another way to incorporate a modern photo into a collage is to extend the photo into the collage itself. Like covering a background, this technique can be employed with paint, collage elements or a combination of the two.

Extending a Photo with Collage

Here, I selected a photo in which the subject's face is very prominent and then cut the face out from the background. I added a bird's body and a hat to make the image more whimsical and collagelike.

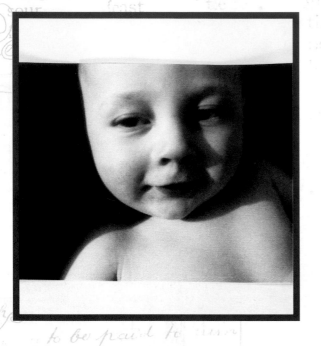 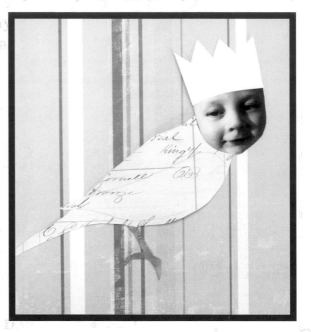

Extending a Photo with Paint

Decide which parts of the image you want to extend beyond the boundaries of the photograph and mix some acrylic paint colors to match those areas. Begin painting on and around the photo. Here, I didn't like how the light was casting a blue tint on my stomach in the photo, so I began by painting my stomach area a more natural skin tone. I then painted down from there, extending my clothes, body and hands. Next I mixed a green paint to match the foliage shown in the photo's background. The final effect blurs the lines between what is a photo and what is a painting—exactly the look I was going for.

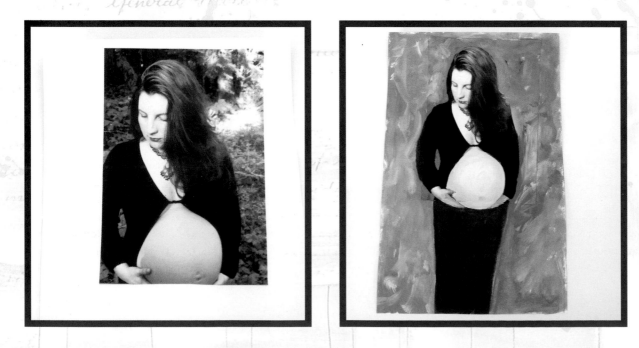

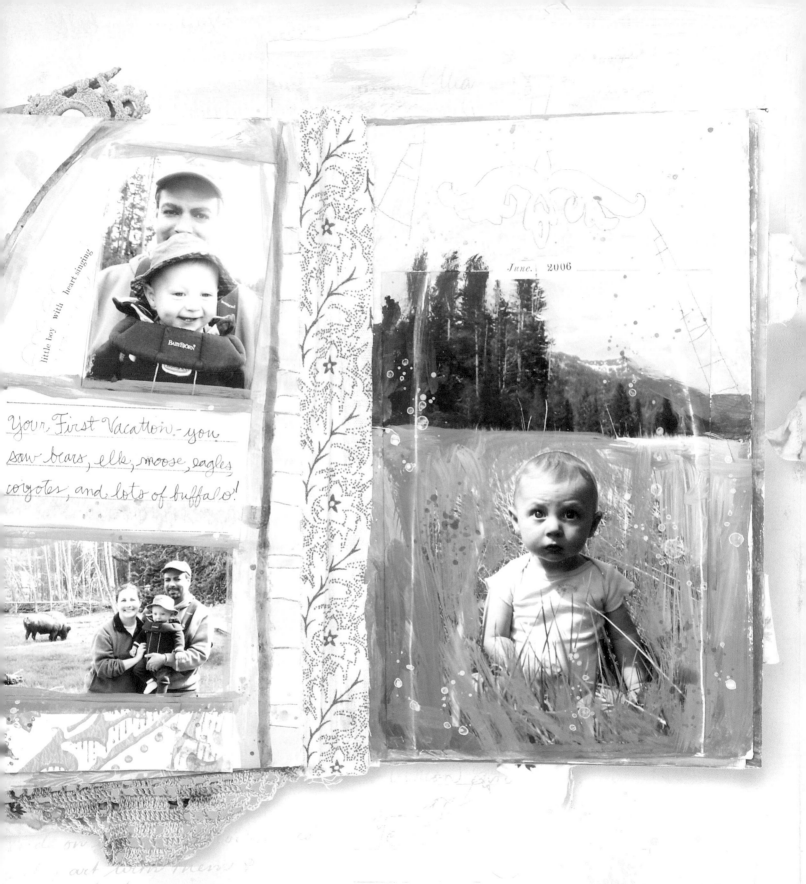

little boy with heart singing

June. 2006

Your First Vacation - you
saw bears, elk, moose, eagles
coyotes, and lots of buffalo!

The photo on the right page of this spread was one of my favorite photos from a trip we took, so I wanted to include it in my son's baby journal. Using the photo by itself seemed stark against the rest of the collage elements, so I painted over the majority of the photo, matching the colors and texture of the background. I extended the photo to fill the entire page and added decorative elements to further tie it into the rest of the spread.

Transferring an Ink-Jet Photo

Ink-jet inks are water-soluble, so photographs printed on an ink-jet printer can be altered with water to create interesting effects. This is an effective way to create a muted, less contemporary image from a modern photo for use in a collage.

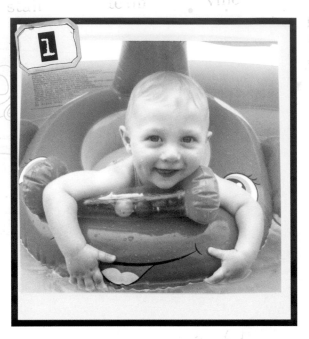

Print image

Print a digital image on photo paper using an ink-jet printer.

Wet image

Use a spray bottle to spritz water over the image. Wherever water droplets land on the image, the ink will be transferred. Spray more water to transfer more of the image or less water to transfer less of the image.

Burnish image

Immediately lay a piece of paper on top of the image and burnish it. (Use a thicker paper so the water doesn't cause it to warp, but avoid overly textured paper, since it will distort the transfer.) I used a credit card to burnish this image while applying even pressure, but you can also use a bone folder or another makeshift tool.

Separate papers

Carefully peel the paper up to reveal the transferred image beneath.

Tip

You can also use this technique to transfer a photo onto fabric with a very tight weave, as I did here.

In *Laugh and Tiny Clothes*, below, I wanted to use soft colors, but the photo I had was in darker tones. So, I transferred the ink-jet print onto a piece of muslin to soften the colors and create a washed-out look.

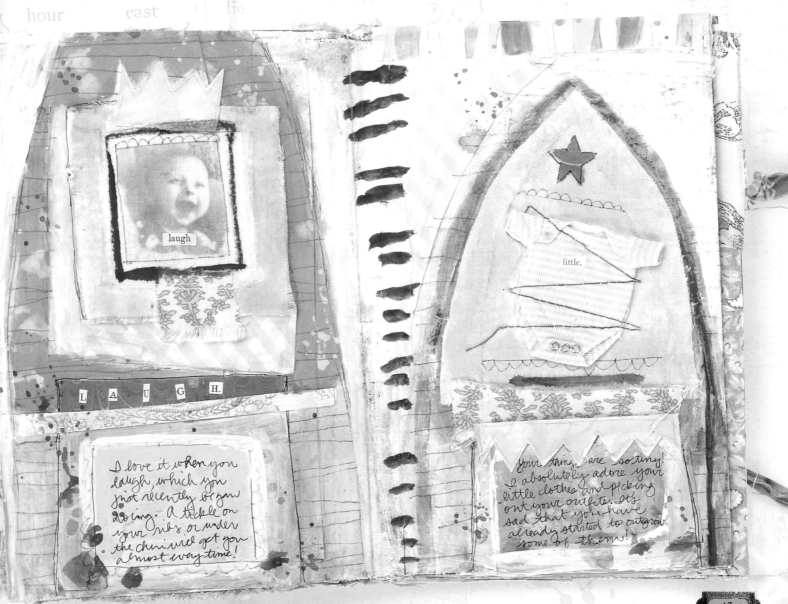

Altering an Ink-Jet Photo

This is a good technique to use with a photo that has dark tones that don't fit the look of a more muted collage, or one you want to soften a bit with texture. By altering an ink-jet photo with water, you can give it a more washed-out, less saturated look to better fit the feel of your artwork.

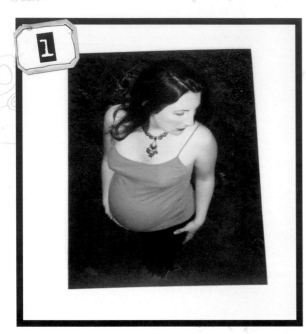

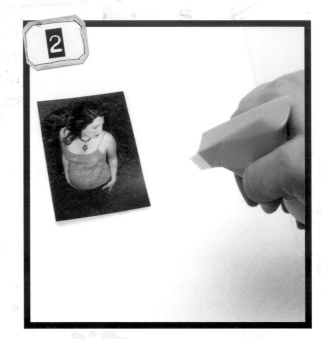

Print image

Print a digital image on photo paper using an ink-jet printer.

Wet image

Use a spray bottle to spritz water over the image.

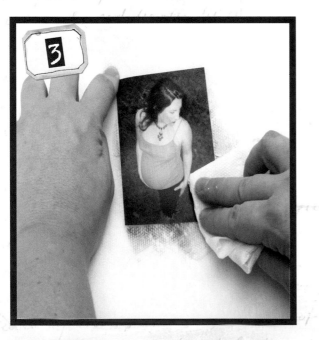

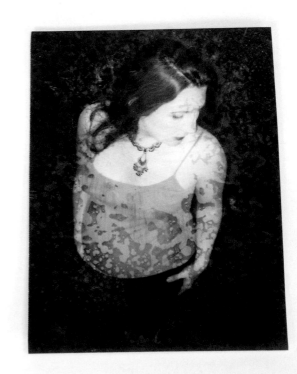

Wipe image

Quickly wipe the water from the surface of the image with a paper towel. The paper towel will also remove some of the ink from the photo, making it appear faded. If you don't like the look the first time, try spritzing and wiping again to remove more ink. If you wish, use more pressure wiping some areas and less pressure on others to create an uneven, splotchy look.

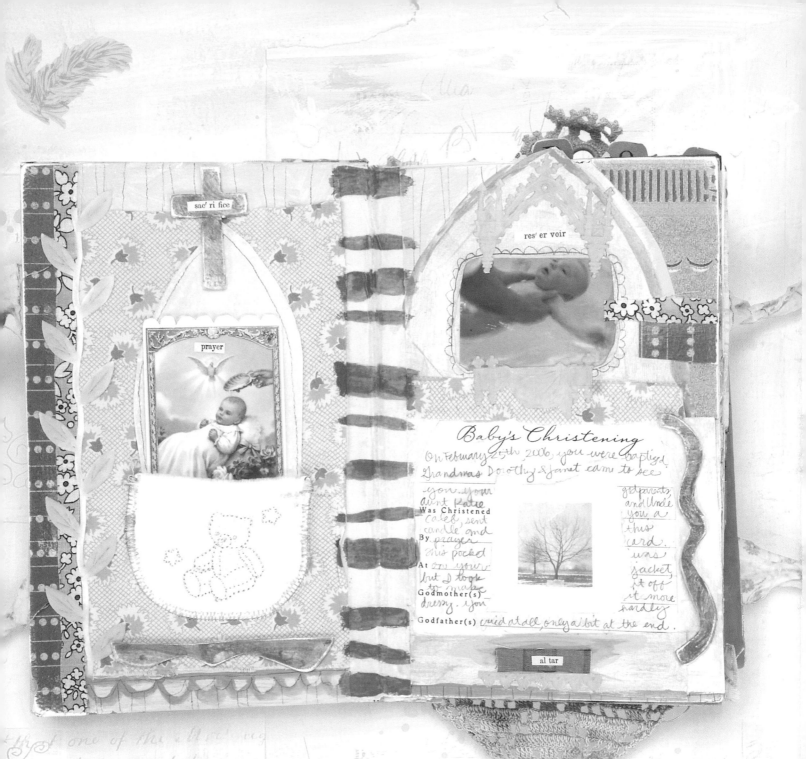

sac' ri fice

prayer

res' er voir

Baby's Christening

On February 25th, 2006, you were baptized. Grandmas Dorothy & Janet came to see you. Your Aunt Katie sent this candle and this prayer. You were Christened this pocket. At your Godmother(s) dressy. You Godfather(s) cried at all, only a bit at the end.

godparents, and Uncle you, a this card. was jacket, it off it more hardly

al tar

This page is about my son's baptism, and the photo I was using had very intense colors. I spritzed the print with water and then wiped away the excess ink, leaving a washed-out, watery result that fit the theme perfectly.

Framing a Photo within a Collage

One of my favorite ways of incorporating modern photos into collages is to frame them with paint and collage materials. I use the term "frame" loosely, as I'm not speaking of a literal frame, just of elements that surround the photo. This technique works because the frame becomes a part of both the photo and the surrounding collage, melding the two together.

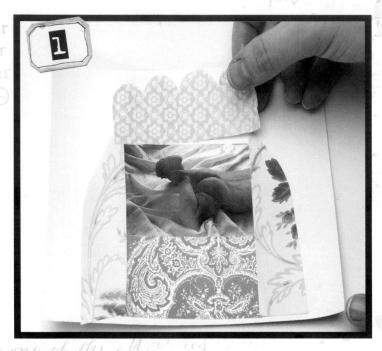

Arrange collage elements

Select a photo and glue it onto the surface of your collage. Cut pieces of patterned papers that coordinate well with the rest of your piece, and begin arranging and adhering them to frame the photo.

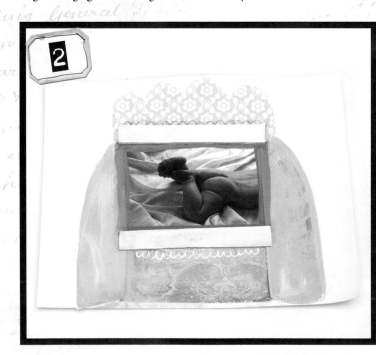

Layer collage elements

Begin the step-by-step layering process, as outlined on page 23. Continue adding paper, paint and embellishments until you achieve the look you like.

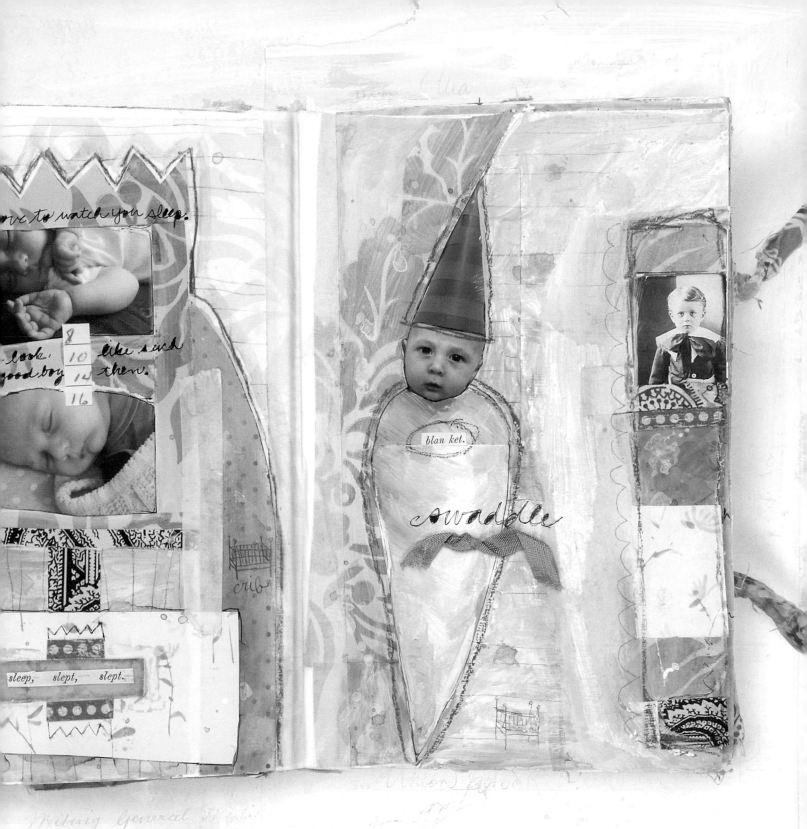

love to watch you sleep.

look 8 10 like such
good boy 14 16 then.

blanket.

swaddle

crib

sleep, slept, slept.

This piece features two photos I wanted to use to
illustrate how sweet my son looks when he is sleeping.
Using decorative paper, masking tape, water-soluble crayons
and pencil lines, I created an elaborate "frame" around the
photos, helping blend them into the page.

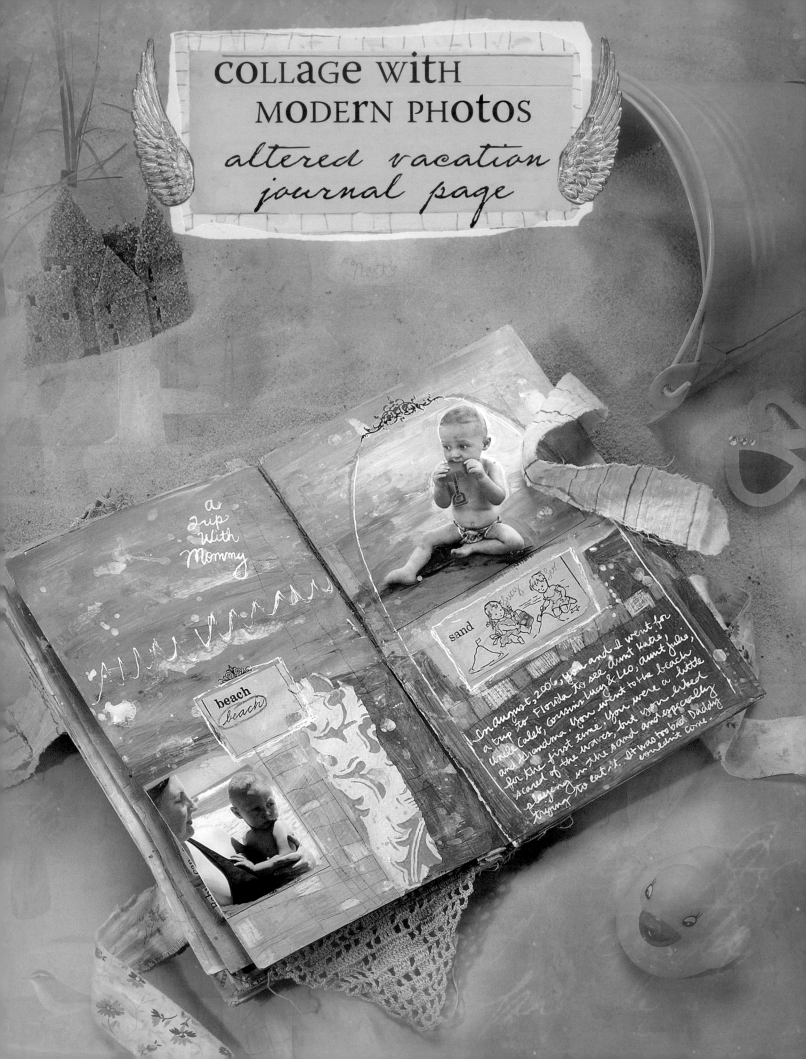

collage with MODERN PHOTOS
altered vacation journal page

a 2up with Mommy

beach *beach*

sand

On August, 2006, you and I went for a trip to Florida to see Aunt Katie, Uncle Caleb, cousins Lucy & Leo, Aunt Julie, and Grandma. You went to the beach for the first time. You were a little scared of the waves, but you liked playing in the sand and especially trying to eat it. It was too bad Daddy couldn't come.

materials

- vintage book
- bulldog clips
- white gesso
- gel medium (optional)
- paintbrush
- photos
- adhesive
- acrylic paints
- paper towels
- scissors
- images cut from vintage books
- vintage wallpaper or patterned papers
- water-soluble crayons
- white gel pen
- graphite pencil
- rub-on transfers

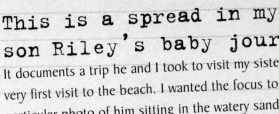

This is a spread in my son Riley's baby journal.

It documents a trip he and I took to visit my sisters and his very first visit to the beach. I wanted the focus to be on a particular photo of him sitting in the watery sand because I felt it captured the wonder of the day. The image really lent itself to being extended with paint beyond the edges of the photo, and the whole layout has a watery, beachy feel as a result. I also wanted to include a photo of myself and Riley because this was the first trip he and I took without his father. For this photo I created a frame with paint, pencil and water-soluble crayons. As I looked for additional collage elements to add to the pages, I came across a drawing of "sand" in a vintage dictionary. It was the perfect find because the little girl and boy in the illustration came to represent Riley's two cousins, three-year-old Luciana and one-year-old Leo, who had come along on our trip to the beach. I added some journaling to complete my record of the experience.

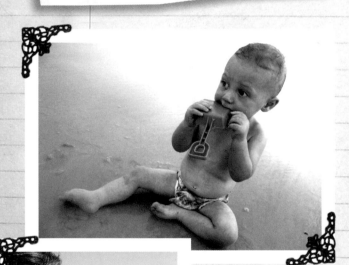

These two photos were my inspiration for this piece.

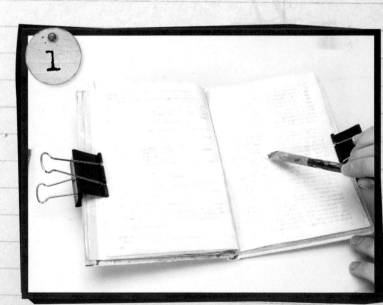

Prepare pages

Take a vintage book, clip the pages open to hold them steady and coat the pages in white gesso to give them some stiffness and tooth. (If you are working with very thin pages, you may want to adhere several pages together with gel medium for added thickness before coating the pages with gesso.) Allow the gesso to dry.

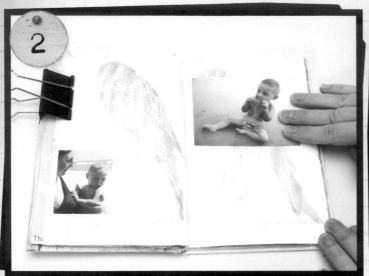

Adhere focal photos

Select two existing photographs from a vacation, event or occasion. Adhere your focal photos to the page.

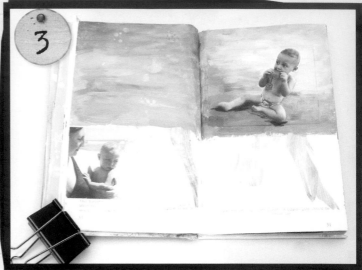

Extend photos

Extend one of the photos with paint (see Extending a Photo on page 40 for more on this technique). Then splatter the paint with water and blot the wet spots with a paper towel (see Splattering Paint on page 18 for more on this technique).

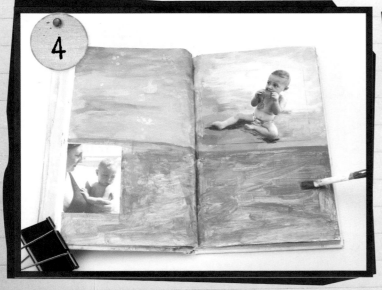

Paint background

Paint the rest of the page with acrylic paint in an accent color from the photo you just extended. Allow a few minutes of drying time.

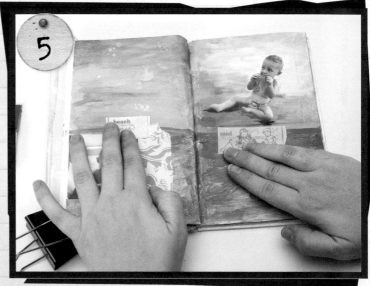

Add collage elements

Adhere additional collage elements to the page with a glue stick. Here, I added a strip of patterned paper and some images that I had cut out from an old book and accented with water-soluble crayons.

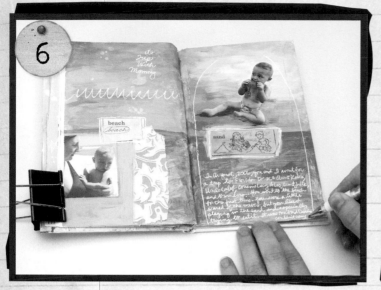

Add detail with pen

Use a white gel pen to add journaling and details to the page. I used the pen to frame my subject with an arch. Add any additional paint details with a small paintbrush.

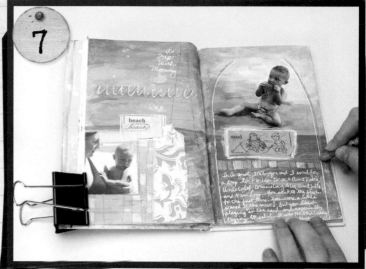

Add detail with pencil and crayon

Add details such as lines or texture using a graphite pencil. I like to go back and fill in some of the areas with water-soluble crayons. Here, I've gone back over some of the white gel pen areas with a water-soluble crayon.

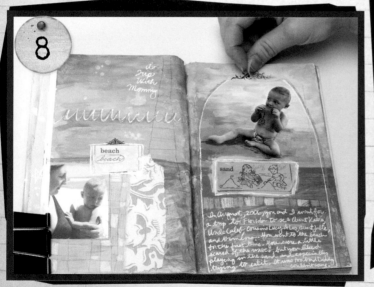

Apply rub-on transfers

In one or two areas, add some rub-on elements.

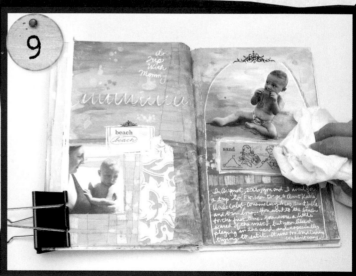

Splatter paint and blot

Finally, splatter some paint on the pages to finish. On this piece, I've used both white and a sand color in different areas. Blot the excess paint with a paper towel as necessary.

Tip

When you extend a photo with paint, the painted surface is a great substrate for additional embellishment. The texture of the paint takes pencil, pen, water-soluble crayons and rub-on details extremely well. Adding these details over the top of the photo helps blur the line between it and the rest of your collage.

One of my main artistic goals is to chronicle my life. As many times as I've tried, I just cannot seem to keep a written diary. Being a visual person, I need the emotional response that comes from an image, and written journals just don't speak to me on an intimate level. At the opposite end of the spectrum, photo albums provide the visual stimulation, but I can't help feeling that they lack emotional depth. This is why my personal artwork is so important to me. Through my collage, I'm able to combine the visual with the written and capture my life, creating pieces that will bring back memories and emotions each time I look at them. It's amazing how viewing a piece of artwork can take me right back to the day I created it and the feelings I was having about the situation.

Incorporating your own photos is one important step toward making your artwork more personal, but there is so much more you can do! What about the events, occasions and interactions that make you "you" and define your life? A collage honoring your parents is wonderful, but how about one that details the day they departed for a second honeymoon in Europe, or one that commemorates their first Christmas as grandparents?

This chapter will be much less technical than the previous ones. Instead of outlining specific artistic methods, I'll give you ideas for illustrating life occasions and personalizing your artwork even further. I'll show you pieces of my own collages in which I've commemorated special occasions, used various mementos and journaled about my life—and, best of all, I'll offer up inspiration for ways you can make artistic expressions of your own adventures.

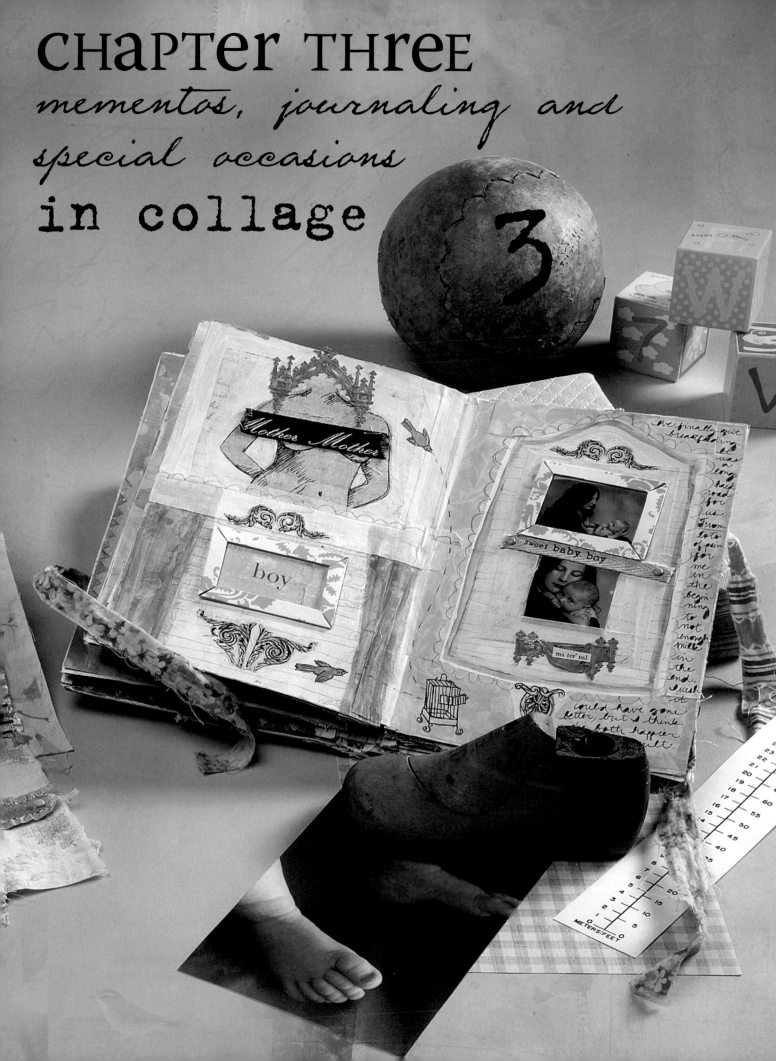

chapter three
mementos, journaling and special occasions
in collage

Using Mementos

Whenever possible I try to use personal items in my artwork. Special mementos from the event I'm illustrating make the artwork even more meaningful and personal, not to mention unique. Using wrapping paper from a specific birthday gift instead of a popular scrapbook paper guarantees your art won't look like anyone else's—and it might just remind you of what was inside that special package. Similarly, using a drawing your child gave you instead of an illustration cut from a children's book guarantees you'll feel a personal attachment to the resulting artwork forever. Mementos can come in many forms, encompassing virtually anything of personal significance to you. Any item you find meaning in can be incorporated into a collage to make it more personal. How about a scrap of the wallpaper you hung in your first house? Or the first sonogram of your baby? Or the gift card from flowers you received to wish you luck at a new job? Or the fabric from a favorite dress? Or some doodles your mother did on her last visit? Or the fortune from a fortune cookie? Or a plane ticket from a favorite trip? The possibilities are endless.

I've used a wide variety of items in my artwork. In my wedding book, two different spreads contain a variety of meaningful scraps. The first, *Wedding Memories* (at right), features three different personal items. At the top is a Barbie bride sticker a friend gave me during my wedding

Wedding Memories (at right); Grandpa's Drawing (below)

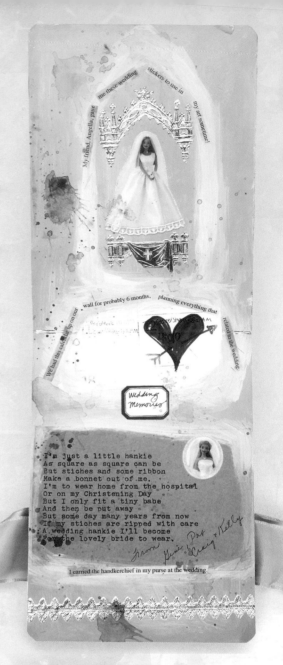

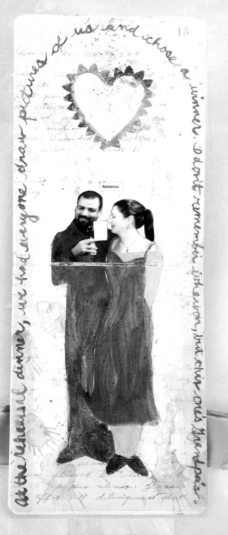

planning. I'm not exactly a Barbie fanatic, but it's a fun reminder to look back upon. In the middle of the page, I've used a piece of the calendar I used to record our wedding planning. This section shows the day before and the day of the wedding, and you can see my notes about family members' arrival times. At the bottom is a poem I took from my own baby book; it tells of a baby bonnet that turns into a wedding handkerchief. Each of these mementos of that day have taken the place of ordinary collage ephemera to make this piece truly representative of the experience.

Another page in my wedding book, *Grandpa's Drawing* (at left), is about a game we played at our rehearsal dinner. We asked each guest to create a drawing of me and my husband-to-be and then chose a winner to receive a prize. I included the winning drawing, which was done by my grandfather, and a photo of us holding that drawing on the page.

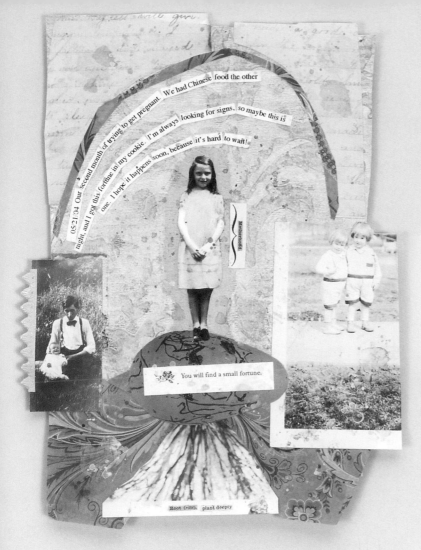

As you can see, I extended the photo (see Extending a Photo on page 40 for more on this technique) since it was cut off at chest level. Although I could have kept the drawing in a box with other wedding memorabilia, displaying it as part of this artwork ensures that I'll remember the context of the piece for a lifetime.

But not all meaningful mementos are tied to special occasions. During our second month of trying to become pregnant the first time, we had Chinese food for dinner, and my fortune read, "You will find a small fortune." I hoped it was a sign we would become pregnant that month, and so I created *A Small Fortune* (at left) with the fortune as the focal point. Even though the fortune didn't prove correct at the time, it's still fun to look back upon this piece and remember the anticipation of finding any sign possible that would forecast our future.

Coincidentally, during my second pregnancy, I also got a significantly phrased fortune in a cookie. I included it in *Small Packages* (below), along with a portion of a card featuring a baby carriage that I received. Even before my children were born, they were collecting keepsakes! Some of my favorite mementos to use are greeting cards and other cards or notes I receive with a gift. To me these are special because of the thought a loved one put into selecting the card or writing the message. Both the printed sentiments on the outside of a card and the handwritten ones inside can be intensely personal and worth remembering.

A Small Fortune (above); Small Packages (below)

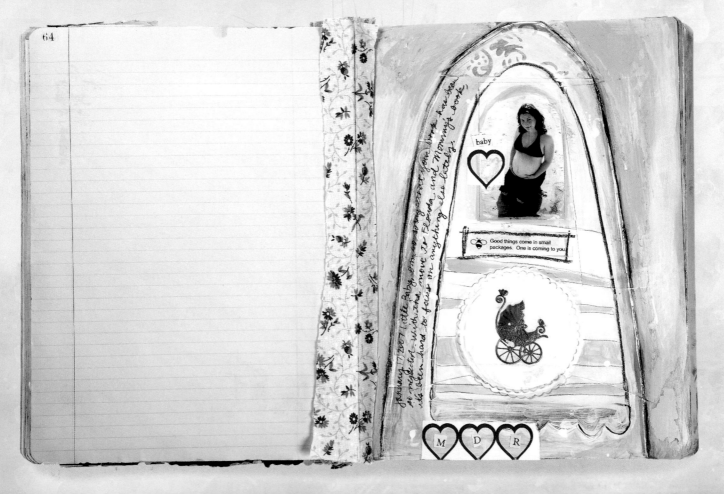

When I discovered I was pregnant the first time, my husband sent flowers to work with a card attached that read, "Congratulations, Mommy." Those two words had such meaning; they told a whole story all by themselves. I built an entire collage (at right) around this piece.

Another example of incorporating this type of memento into collage is the spread I did in Riley's book for my first Mother's Day (below). My husband gave me cards both from himself and from my son, and I couldn't bear to just hide them away. So I cut out the sentiments he had written, "framed" them (see Framing a Photo within a Collage on page 46 for more on this technique) and added other elements referring to the day to complete the pages. This is one of my favorite pieces of art solely because of the personal elements it showcases.

When incorporating memorabilia in your work, don't limit yourself to paper items. In the piece displayed on page 45 about my son's baptism, I used a pocket I cut from the pants of his baptism suit. Inside it I placed a holy card his godparents had given him. I then journaled on a christening announcement his grandmother had given me and included that, as well. These items, combined with the photo of the event, create a highly sentimental piece of art.

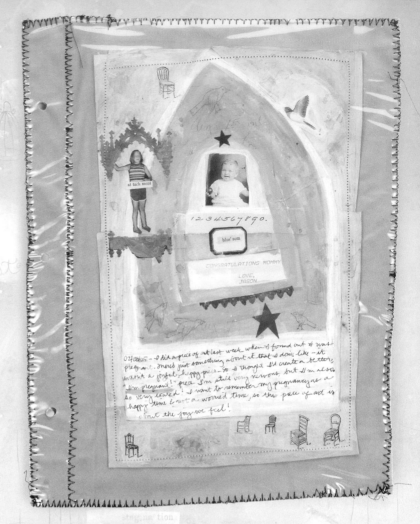

Congratulations, Mommy (above); First Mother's Day (below)

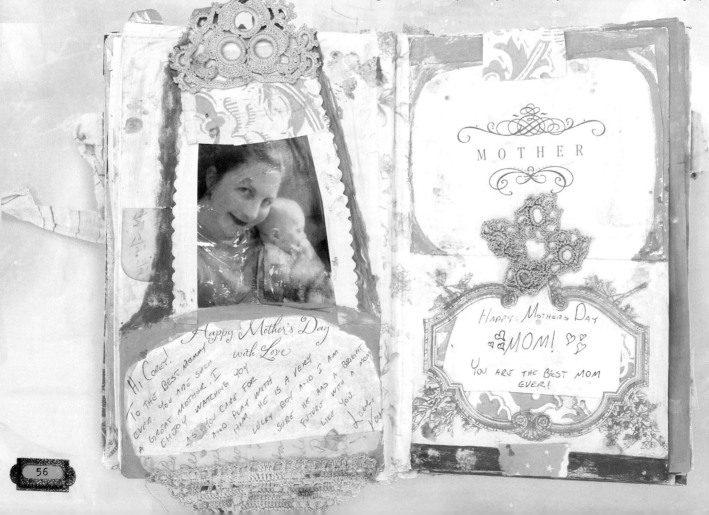

These meaningful items don't necessarily need to be things you've collected. Nothing says you can't manufacture your own mementos! For instance, I've used my baby's handprints in several pieces of art. I knew I wanted to commemorate how tiny his hands and feet were when he was born, so I made several sets of hand- and footprints specifically for use in my artwork. *Babyhood* (at right) hangs in my son's bedroom. It features his photo, his hand- and footprints, his name and other decorative elements. On other pieces, I've painted his hand and put his handprint directly onto the artwork, such as on a Father's Day piece I created for my husband (see page 39). Think of other ways you could make your own memorabilia. Maybe you could have your child write her name on a piece of paper and include it in a piece of art. Or you could make a lip print with your favorite shade of lipstick for use on a piece about your anniversary.

Although these things may not be your typical collage materials, they really aren't much more difficult than traditional ephemera to incorporate into your artwork. In fact, lots of these items are made from paper, and as collage artists, scrapbookers or art journalers, we're no strangers to working with that!

In fact, many of the techniques I outlined in the last chapter for including modern photos in your collage will also work for other bits of memorabilia. Again, the trick is

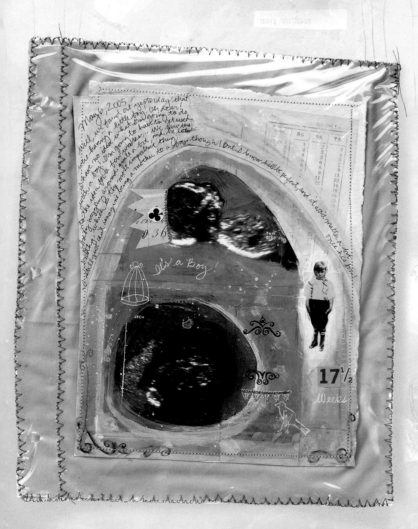

It's a Boy (at left); Babyhood (above)

to use paint and other elements to blur the line between the personal item and the rest of your collage so the end result is one cohesive piece. You can see on *It's a Boy* (at left) that I've included sonogram images from the day we learned Riley was a boy. To blend them with the look and feel of the rest of the piece, I employed a couple of different techniques from Chapter Two: I extended one sonogram "photo" by adding a crown to the baby's image, and I painted around another sonogram image to frame it.

Different "modern photo" techniques are appropriate for different mementos. Once you start experimenting, you may discover new techniques on your own! Regardless of how you choose to incorporate these special items, do push yourself to use them in your work. They will make all the difference in creating meaningful and significant art.

Using Journaling and Words

Another essential component to making your artwork more personal is the addition of words to supplement the visual elements of your piece. By adding your own thoughts in writing, you are putting even more of yourself into your work. While I don't keep a written diary, virtually every piece I do has some text on it, and this serves as its own sort of journal, one I'm sure my friends and family will appreciate just as much as they look back upon my art in the future.

The *Laugh and Tiny Clothes* spread in Riley's journal on page 43 illustrates the added effect words can have. If you were to cut off the bottom half of each page, the imagery could stand alone and still have meaning. You can see the cute picture of him laughing and also the little onesie sewn to the page and gather that the spread has something to do with those things. But the pages evoke even more emotion when you can read my thoughts detailing his first laughs and how much I love his tiny baby clothes.

You can further personalize your art with the simple addition of as little as one word or as much as a couple of paragraphs. If you don't want to handwrite on a piece, that's fine too. I know lots of people who hate their handwriting and couldn't bear the thought of "ruining" a piece by writing on it. There are plenty of other options for adding text to your art: You can type it on your computer and print it out, use rub-on transfers or cut phrases from

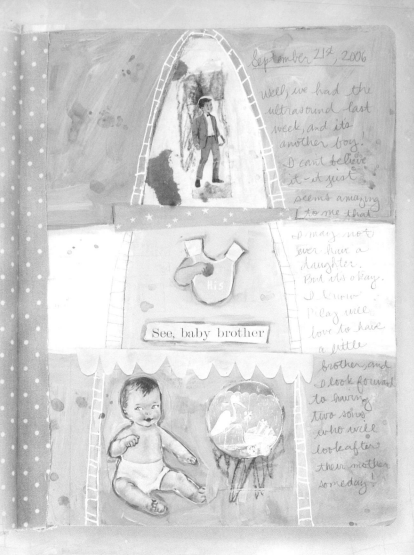

See, Baby Brother

a book or magazine. Take a look at these examples of various types of journaling from my own work (at left).

When I'm adding a lot of journaling, I use any number of these methods, but usually I stick with handwriting. There is something to be said for recording your thoughts in your own hand, and it's also usually the quickest method. In *See, Baby Brother* (above) from my second pregnancy journal, I used words cut from a vintage book in the central part of the piece but handwrote the journaling. This page is about learning the gender of my second child, so I wrote about my feelings behind the results. Not only does the handwriting add a personal touch, but since it's lightly written in pencil, it doesn't detract from the focal images as much as another method might have. If you are worried about "messing up" while you write, use a water-soluble pen or pencil so you can use a wet paper towel to wipe away any mistakes and start again.

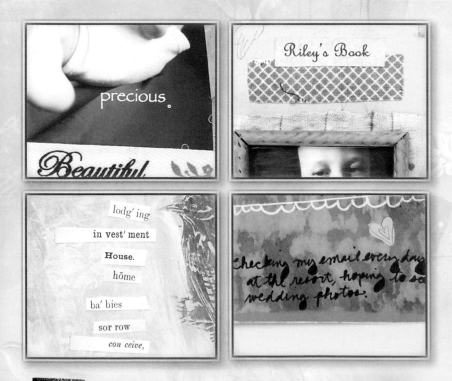

Some artists also struggle with not knowing what or when to write on a piece of art. This is a matter of personal preference. Some people prefer to leave space for journaling when they create their artwork, and then go back at a later time and add text. Usually this results in writing that doesn't necessarily relate to the imagery since it was done at a different time. I prefer to add the text while I'm creating the piece so I can capture my thoughts most accurately.

Write whatever feels natural to you, and be as specific or nonspecific as you'd like. I usually write something pertaining to the topic of the piece, but maybe you'd be more comfortable writing something more general, perhaps a list of things that made you smile that day. Or you might opt to include quotations or poems to convey your thoughts. For instance, *Very Few of Us* (at right) was one of the first pieces in which I used my own image. The imagery seemed to have a lot of confidence and strength to it. I found this quote: "Very few of us in this world find ourselves," and felt it summed up my feelings perfectly. One of the things I'm proudest of in life is that I have found myself through my artwork, and I realize how lucky that is. And in *Six Months Old* (below), which I created when Riley reached that age, I used the text from a poem I found about a mother's feelings for her eldest child.

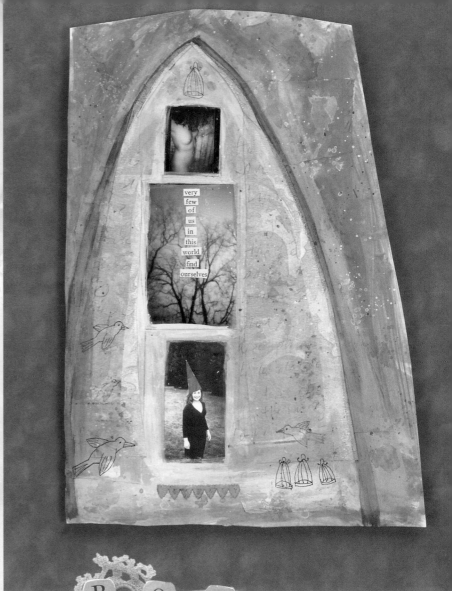

Six Months Old (at left); Very Few of Us (above)

When first thou camest, gentle, shy, and fond,
My eldest born, first hope, and dearest treasure,
My heart received thee with a joy beyond
All that it yet had felt of earthly pleasure;
Nor thought that any love again might be,
So deep and strong as that I felt for thee.

The Mother's Heart

If you don't like the look of a lot of text, or you don't want a play-by-play of your day on each piece, or you simply prefer to keep things more mysterious, one well-chosen word or phrase can capture an entire mood or emotion. *Stagnation* (at right) is a piece I did while trying to become pregnant. I used an image of a baby inside a shrine, then next to it an image of an empty shrine to represent our months of unsuccessful attempts. It was a time when we felt we were not getting anywhere. Just looking at the imagery of the piece, you may not take away this meaning, but the addition of the word "stagnation" conveys the mood without going into specifics.

Stagnation (at right); Trappings (below);
Yearn (bottom right)

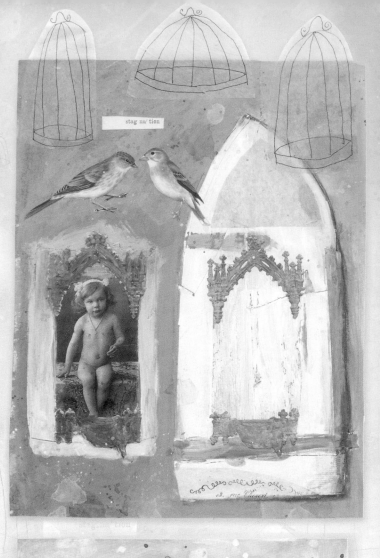

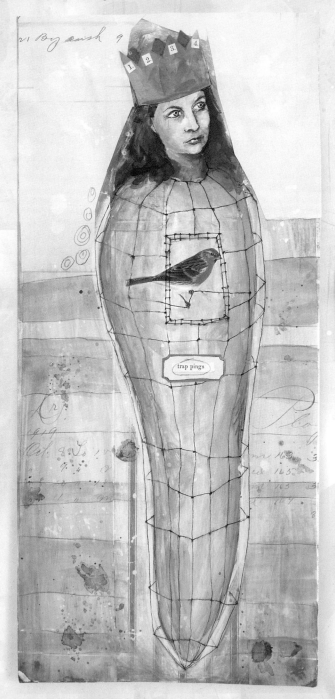

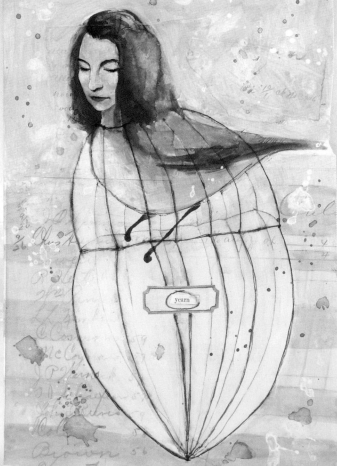

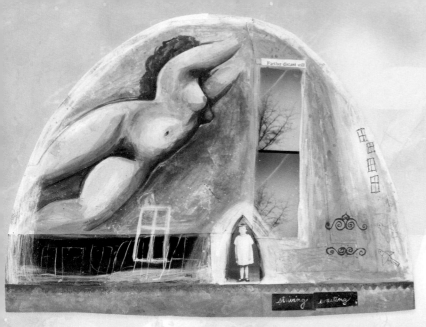

Striving, Waiting

as though we would never reach our goal. I handwrote the words "striving, waiting" to emphasize the theme, but looking back at the piece now, that serendipitous phrase from the book holds the most meaning.

Composition-wise, there are some things to be considered when adding text to your collage. While it's not a necessity, it helps if you know ahead of time whether or not you're going to journal on a piece, so you can allot a balanced space for it. Simple words or phrases don't require as much forethought, but a longer journal entry takes up a significant amount of space.

This is especially true in my art journals (obviously!). As I'm designing pieces in these books, I always know in the back of my mind that there needs to be some space left for writing. Sometimes this simply means that I don't embellish in one area so that there's a neutral background for the words. *I'm Pregnant Again* (below) from my second pregnancy journal is a good example of this. Other times, I create a specific spot to later fill with written insights. For example, when I created *Newborn* (shown on page 14), I used a block

Conversely, if I'm doing a more general piece without a theme, I'll often use a single word or a short phrase to add a hint of meaning. I don't usually have a word in mind when I begin. I just let my mind wander while I'm working, paying attention to where it goes and drawing from those thoughts once my piece is further along. *Trappings* and *Yearn* (on the opposite page) weren't intended to be about anything in particular. I had images in my mind of my face attached to a foreign body with some sort of cage around it, and I wanted to get them out on paper, though I didn't quite know what was behind them. As I worked, my mind began to feel the emotions of the subjects of the paintings, and by the time I was finished, I had a clearer picture of what I'd been trying to express: The words "trappings" and "yearn" were fitting sentiments.

When I'm feeling stuck and want to jump-start my creative self-expression, I like to look through vintage books, including dictionaries. I love the aged paper and the uncertainty of not really knowing which word or phrase I am looking for—but having confidence that I'll know it when I see it. Sometimes it takes fifteen minutes or more of flipping through a book before the perfect word or phrase jumps out at me, but I think the serendipity of the right words revealing themselves adds to the art. This is all part of "listening" to what your artwork is telling you as you work.

Another piece I did while trying to become pregnant (see above) includes a painting of a woman stretching and reaching. In struggling to express the meaning of the piece, I spent some time looking through an old primer I had. The phrase "farther distant still" eventually jumped out at me. It perfectly conveyed what I wanted to express: feeling

I'm Pregnant Again

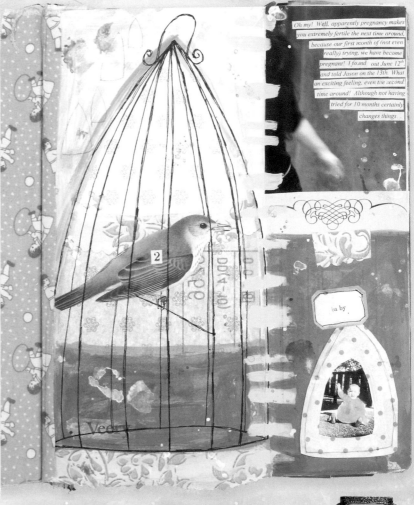

of lined paper as a design element and then later filled it with my thoughts. When I'm creating my compositions, I don't necessarily plan out what form the journaling will take, and often, my idea changes as I work on the piece. Freeform creation can work well as long as you make sure the composition doesn't become too crowded.

You can also be creative not just in what you write but in how you write it. I do my writing in all kinds of configurations, shapes and directions. In *Early Bird* (below), most of the text has been wrapped to follow the lines of shapes in the artwork. I've also used more than one method of adding text. The phrase "this baby gets out of bed early in the morning" was cut from several different places in the same book and pasted together.

Usually, I don't add the text until I'm almost finished with a piece. Because the writing can be done in so many ways, it's nice to see what the final piece is looking like before I decide which type would work best. Waiting until a later stage also means the writing can be shortened or lengthened depending on how much space there is. In *Fifth Month* (opposite page), I wanted to convey that during my son's fifth month, he had learned to roll over and had gotten his first teeth. By the end, however, there was quite a bit going on, so I simplified the text to the very minimum: "fifth month, rolled over, grew teeth."

As you've probably gathered, I'm a big a fan of themed art journals. My passion began with my wedding journal and then progressed to a pregnancy journal, Riley's baby journal and now to my second pregnancy journal. Art journals, by definition, are the perfect venue for adding text to your artwork. Because they are themed, it's easy to keep a running commentary about the chosen subject throughout the book.

Early Bird

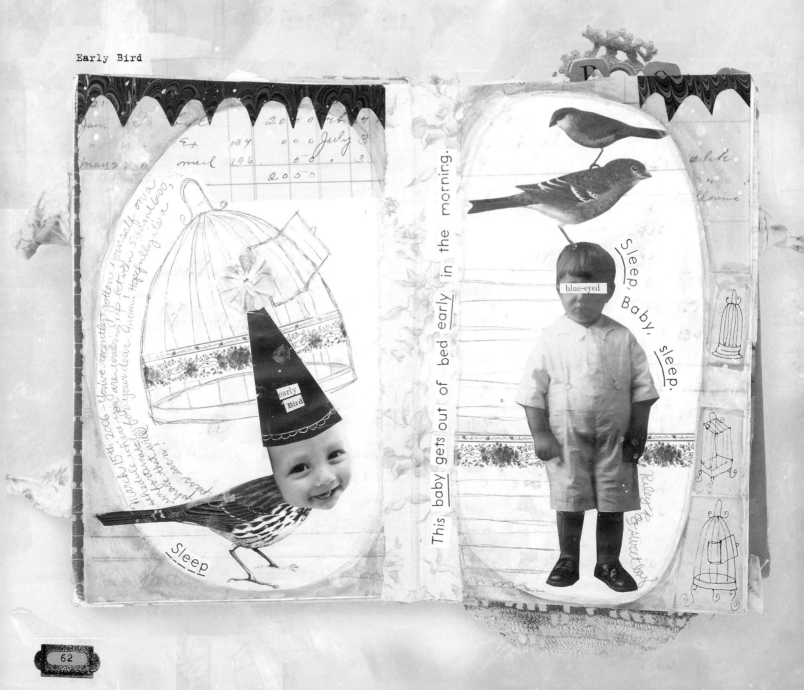

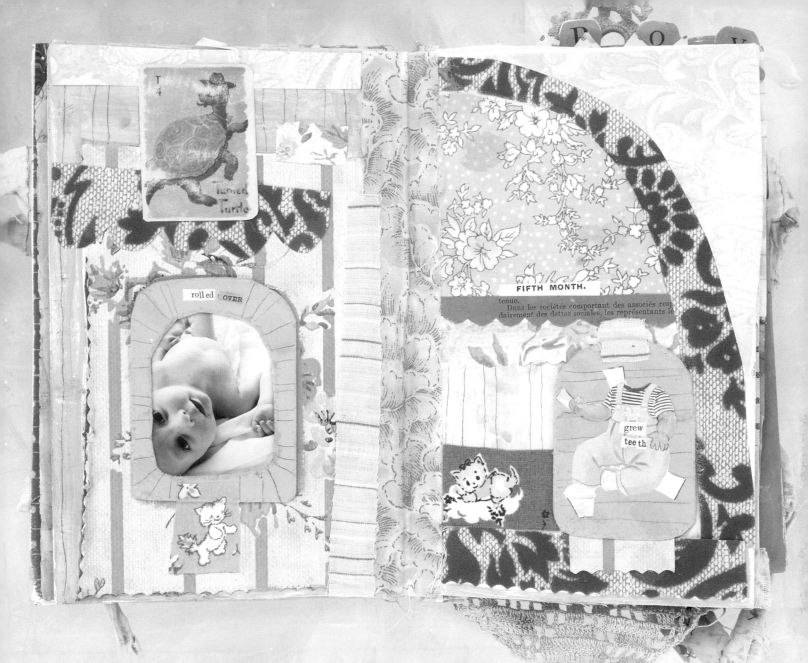

Turned Turtle

rolled OVER

FIFTH MONTH.

tenue.
Dans les sociétés comportant des associés resp
dairement des dettes sociales, les représentants le

grew
teeth

Fifth Month

This may be the perfect way to get started journaling on your artwork. Choose a subject, maybe not even a terribly significant one (so it's not intimidating), and begin doing artwork about it in a small book. Experiment with different ways of adding words to see what feels comfortable to you. Maybe you can start a journal about a garden in your backyard. Take notes about what you've planted or what the weather's like, and then progress to recording the thoughts you have while you're in the garden and the emotions that arise as you're working in it.

Or, if an art journal isn't your thing, try adding single words to pieces of your artwork. Set a goal that each collage you do from now on will have a word or phrase on it that expresses the emotions behind the piece. Let your mind wander while you work and see which words reveal themselves, or approach your goal a different way and create an entire piece of art about a word or phrase.

Using journaling and words in your art will do nothing but enhance it. Sometimes the words take a prominent position in the composition, and sometimes they are secondary to the main subjects. I write about all sorts of things, from menial tasks to my deepest emotions, and I add words and phrases throughout my pieces, expressing a variety of things. But regardless of what is written, words invite the viewer in, encourage thought and create even more of a connection to you, the artist.

Holidays, Occasions, Milestones and Events

One of the ways to begin this sort of visual diary is to do pieces illustrating annual holidays and occasions—birthdays, anniversaries, etc. Since these events occur annually, they are great gauges for looking back upon your life, noting family traditions as well as exciting changes from year to year. In addition, they are usually sentimental events that lend themselves to being illustrated in your artwork.

Three years ago I decided that every year on my birthday I would do a commemorative piece of art. The first, *32nd Birthday* (at top right), is fairly straightforward. (I was still floundering with making my artwork more personal back then!), stating the date and showing girls with birthday hats. The words "Celebrate" and "Birthday Girl" emphasize the theme. Although it's not a terribly personal piece, it makes a statement about the day—and it's become a landmark I can look back upon to see how my art has changed since then.

As with my other work, my birthday collages have evolved, becoming yearly statements of what I've accomplished. In my *33rd Birthday* collage (at bottom right), I listed several words representative of the year's major events: "lodging," "investment," "house," "home," "babies," "sorrow," "conceive," "joyous," "maternity" and "fulfill." The year had been one of life changes: We decided to purchase a house, tried for several months to become pregnant and, finally, conceived our son. Just this simple list can do a lot to spur memories of that time.

For my *34th Birthday* piece (opposite page), I illustrated the year with important images rather than words. An image of a house represents our experience of settling in. Beneath that is a piece of sentimental memorabilia—a portion from the birthday card my husband gave me—as well as a photo of our son. The main image is of me, holding all these things in a birdcage sort of shape, which you might say represents me trying to handle it all.

I anticipate next year's birthday piece to be even fuller. What fun it will be to look back at this collection twenty years from now and see where I have been and what I have become.

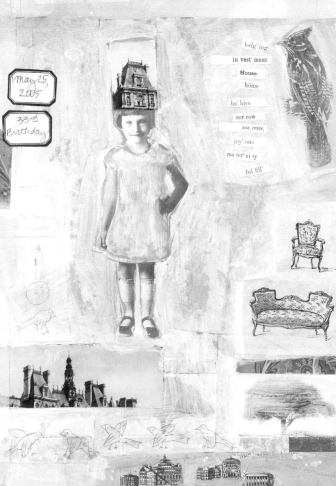

32nd Birthday (above); 33rd Birthday (below)

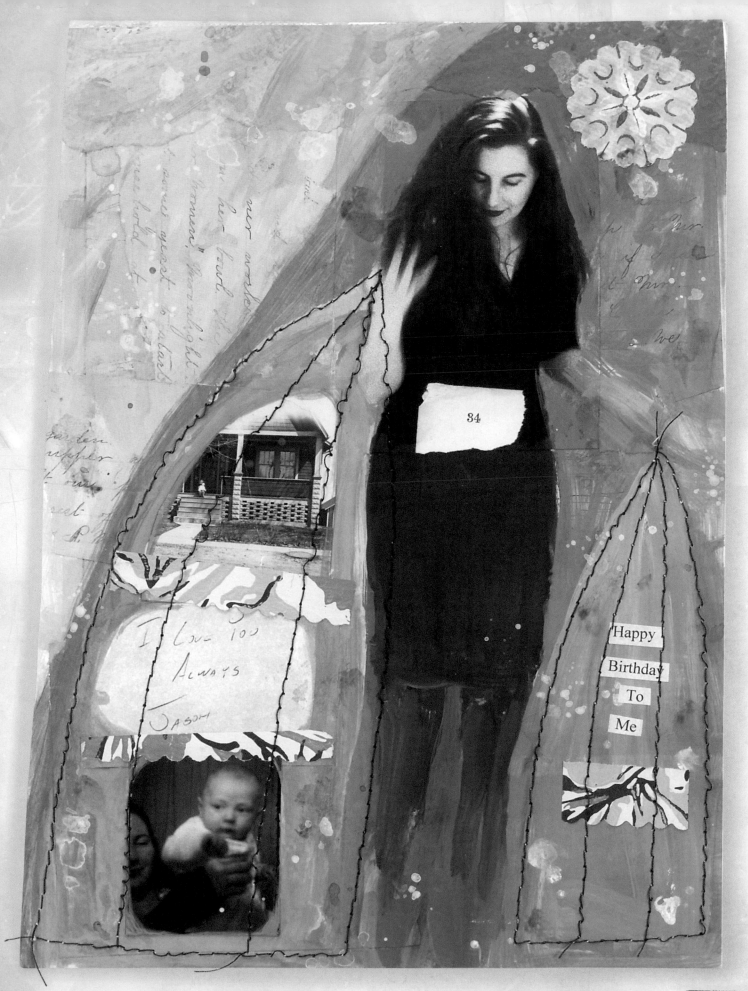

34

I Love You
Always

Jason

Happy
Birthday
To
Me

34th Birthday

Try creating your own birthday artwork in much the same way. You might also honor friends or relatives by making commemorative collages for their birthdays. I created a piece for my sister's thirtieth birthday (at right) to recognize all she had achieved leading up to that milestone. What better way to let your loved ones know how proud you are of them and how much you care about them?

Other annual occasions are obvious choices for artwork as well: For instance, you could do something similar for New Year's Day (perhaps artwork that lists your resolutions each year) or Thanksgiving (consider artwork that depicts all you're thankful for). Virtually any special day—Valentine's Day, Mother's Day, Easter, the Fourth of July—is full of fodder for your work.

```
1st Anniversary (below);
Julia's Thirtieth (at right)
```

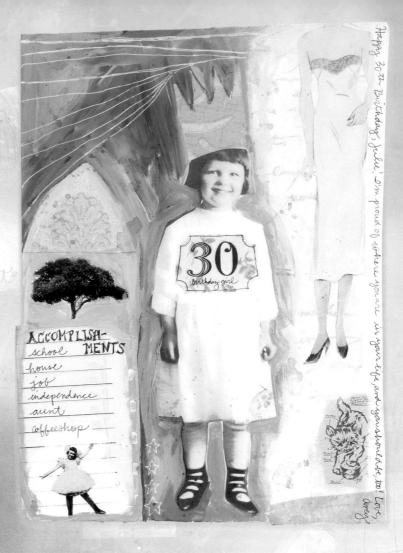

The more intensely personal the occasion you wish to honor, the more intimate your resulting artwork will be. For example, I made a piece for my husband (at left) on our first wedding anniversary. Since paper is the traditional gift for that milestone, I felt a collage was especially appropriate. I used an image from our wedding day and embellished it with wings, ribbons and the words "Happily Ever After."

Similarly, for my husband's first Father's Day, I created a piece (see page 39) featuring photos of my son and husband together, as well as a list of things that are special about their relationship in the "voice" of my son, such as, "He's better than Mommy at making me laugh," and, "He's going to teach me how to use tools someday." I also put my son's handprint on the piece with paint.

In addition to the obvious days, think about other occasions that warrant artwork: those moments and milestones that define our lives perhaps even more than annual events. Weddings and births and first steps, life decisions and important choices—we usually take photos of these occasions, so why not create artwork about them as well?

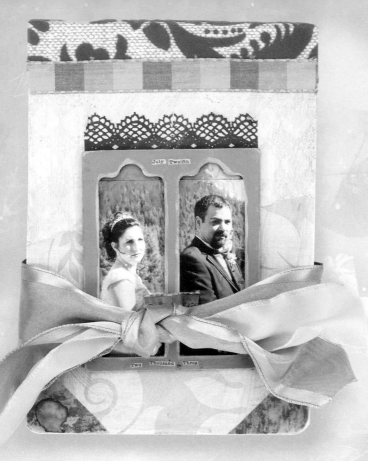

In the journal I created about my wedding and honeymoon (shown at left), I captured many memories I didn't want to forget: my husband proposing, my mother helping me choose my wedding dress, my sister and I traveling three hours to retrieve candles we had forgotten to pack (bottom left), my husband crying when he saw me walking down the aisle (bottom center), our honeymoon (bottom right) and a lot more. Any occasion that requires so much planning and involves the whole family—a family reunion or a big vacation, perhaps—would lend itself to this type of visual tribute.

You've also already seen several examples from my pregnancy journal. Over the course of about a year and a half, I created twenty-four pieces that chronicled our path, from the decision to try to become pregnant up to Riley's birth. The beginning pieces were positive and excited, such as *A Small Fortune* (page 55).

The cover and three spreads from my wedding journal

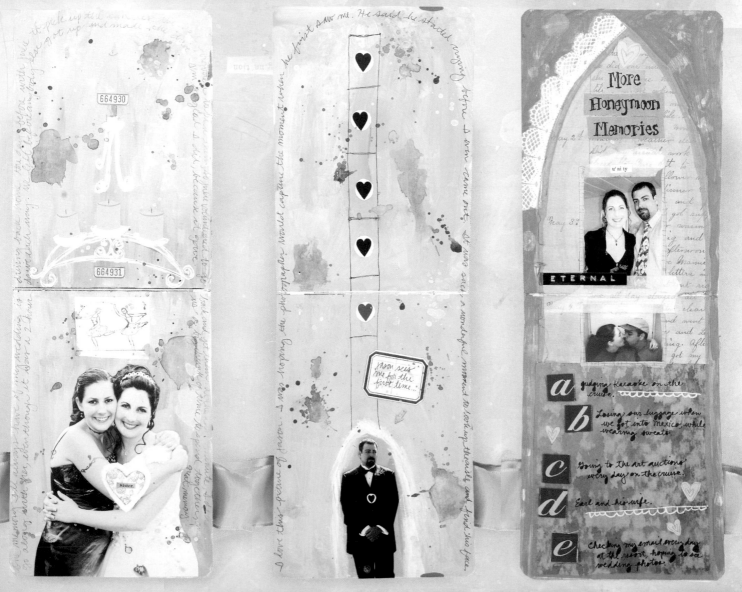

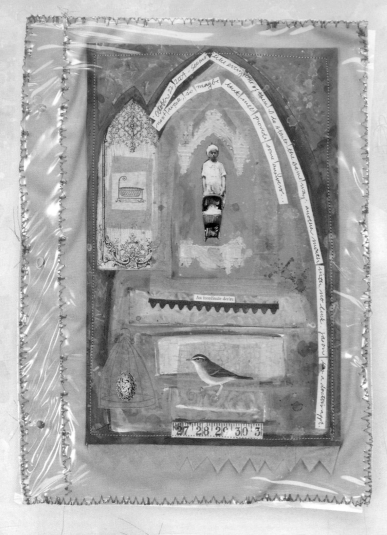

But after months without conception, the artwork took on a different tone. In *Detained* (below), phrases like "no baby this month" and "detained by waiting for something" show my state of mind. And *An Inordinate Desire* (at left) states, "Seems like every one of these I do starts the same way—another month with no luck," and shows a solemn girl pushing a baby carriage. Although these months weren't joyous ones, they were important and real parts of our story. These honest chronicles of our struggles make the pieces reflecting our eventual success that much more meaningful.

The first piece of art I did after learning I was pregnant (on the opposite page) is a painting of a nude woman with "hanging by a thread" written in the womb area. This was how I felt the first few days—like the pregnancy was so delicate, it could end at any second. Not a very positive thought! A few days later, I began to regret not having created a more joyful piece of art when I'd found out the good news. So I decided to relax and let myself enjoy the moment, and I did another piece, *Congratulations, Mommy* (see page 56), featuring a laughing baby and the word "blossom." It's quite interesting to look at the two

An Inordinate Desire (at left); Detained (below)

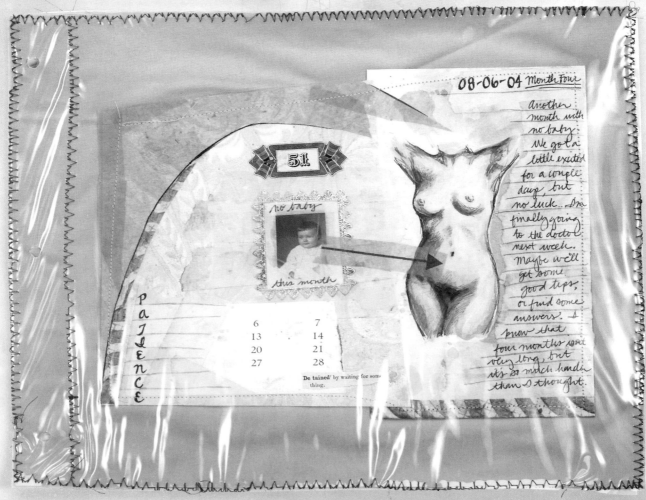

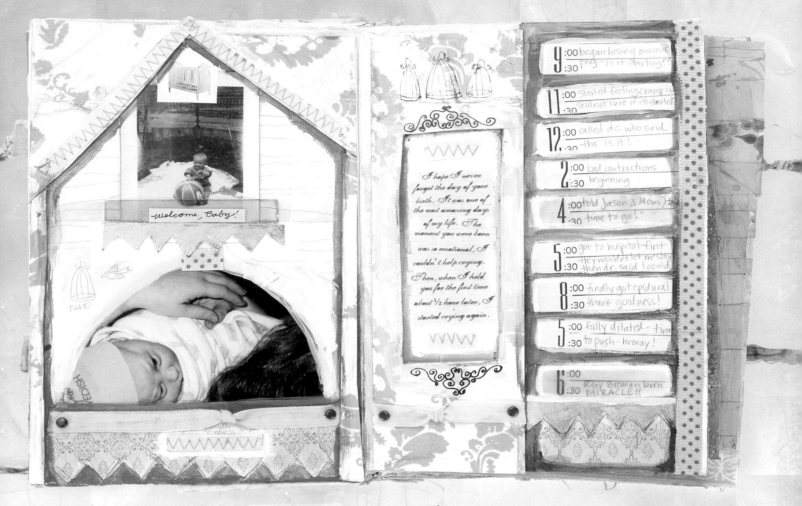

9:00 began losing mucous
:30 plug—is it starting??
11:00 started feeling cramping
:30 still not sure if it's started
12:00 called dr. who said
:30 "this is it!"
2:00 bad contractions
:30 beginning
4:00 told Jason & Mom "it's
:30 time to go!"
5:00 got to hospital—first
:30 they wouldn't let me stay then dr. said I could
8:00 finally got epidural
:30 thank goodness!
5:00 fully dilated—time
:30 to push—hooray!
6:00
:30 Riley Brennan born MIRACLE!!

Welcome, Baby!

I hope I never forget the day of your birth. It was one of the most amazing days of my life. The moment you were born was so emotional, I couldn't help crying. Then, when I held you for the first time about ½ hour later, I started crying again.

Riley's Birth (above); Hanging by a Thread (at left)

pieces together. The first is muted and quiet, whereas the second is colorful and has more movement. Both accurately reflect the emotions I was having during that pivotal time.

These pieces were intensely personal, but so much of a pregnancy is shared with loved ones that you'd find plenty of fodder to create a meaningful pregnancy collage for any close friend or family member. Try focusing on milestones: the first ultrasound, hearing the heartbeat, finding out the gender, decorating the nursery, etc. Then, when the big day comes and the baby arrives, you can begin a new homemade baby book for both the new proud parents and their new addition to look back upon for years to come. The first spread in the book I created for Riley listed his birthday's events, hour by hour (above). I didn't want to forget one minute of it! I also included a photo taken of the first minute I held him (one that still brings tears to my eyes when I see it).

These days, almost every piece I do is about some milestone in our lives. You may even find that some occasions warrant being revisited in your artwork after some time has passed. For example, when we had the ultrasound

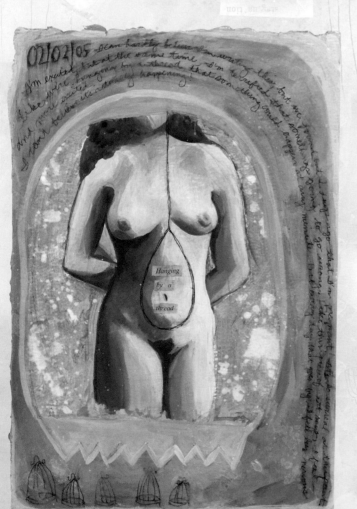

02/02/05

Hanging by a thread

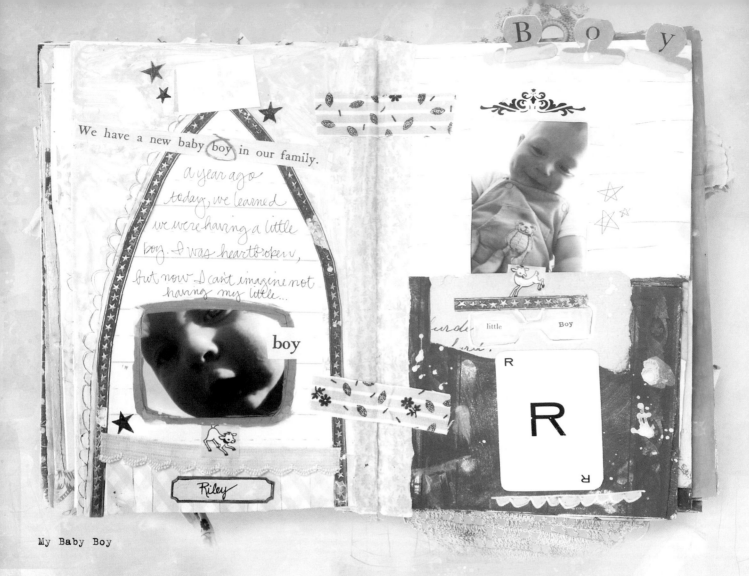

Within the artwork, the following text appears:

B O y

We have a new baby boy in our family.

a year ago today, we learned we were having a little boy. I was heartbroken, but now I can't imagine not having my little...

boy

little Boy

Riley

R
R

My Baby Boy

confirming Riley's gender, I created a piece of art, *It's a Boy* (see page 57), reflecting my conflicted emotions. My whole life I had wanted daughters, but the universe had different plans. Finding out I was having a boy took some getting used to! On the one-year anniversary of getting this news, I felt the need to reflect my new outlook on the matter with a fresh piece of art (above). How could I have ever wished for a little girl instead of my sweet boy?

These pieces of art that detail important moments and milestones in your life (whether positive or negative) will bring back vivid memories every time you look at them. They certainly are a testament to the value of personalizing your artwork! Even if the imagery in the art has nothing to do with the event of which you speak, just some words describing the milestone are enough to trigger the memories. For example, I did this self-portrait painting (opposite page) on the day we were trying to decide whether or not to purchase a particular house. Some technical problems arose at the last minute, making us wary of the purchase. At the end of the day, once we had made the decision, I added the journaling at the bottom of the painting. Every time I see this piece, even though there are no "house" references in the imagery, I remember that day.

Sometimes these less celebrated moments are perhaps most worthy of illustration because they are uniquely your own experiences—no one else's. Think about ways you could apply some of these ideas to your own artwork. You might create a journal detailing a big project, such as remodeling your house, training for a marathon or learning something new, like how to cook or knit. Even non-life-altering events should still have a place in your artwork. Why not do a piece about housebreaking your puppy, or buying a new car, or making a new friend, or getting some kind words of recognition from your boss? These everyday moments make up most of your life, so they should not be forgotten in your artwork. You should also resist the urge to gloss over the darker days. You might find it a therapeutic experience to create art expressing your anxiety over losing your job, or your grief about the death of your grandfather. Good or bad, all these things affect your life and make you who you are.

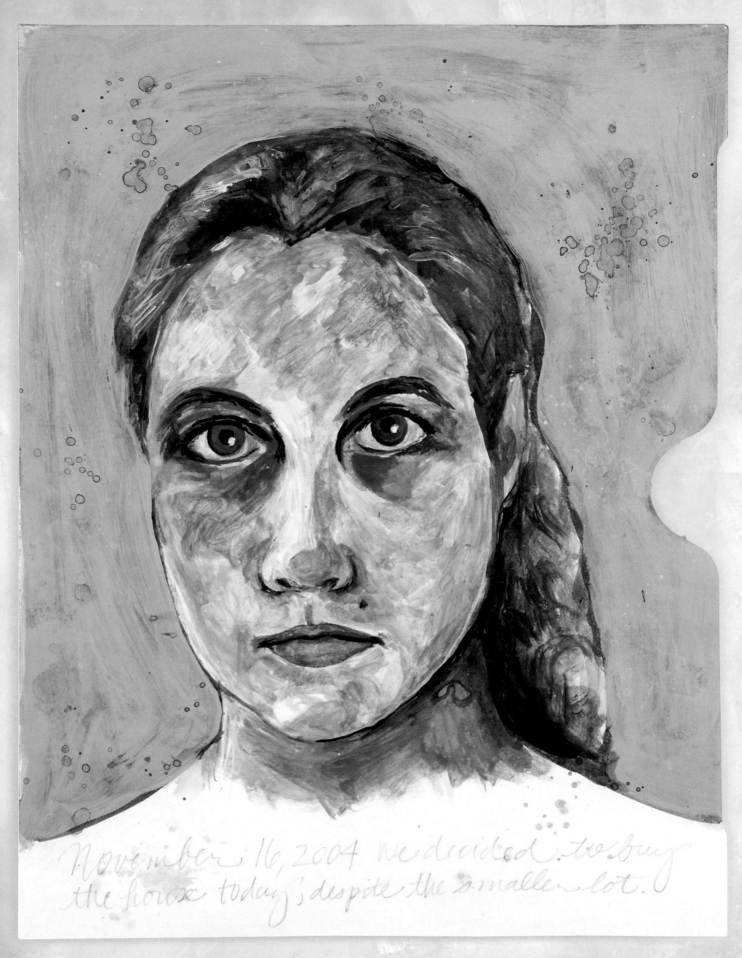

November 16, 2004 We decided to buy the house today, despite the smaller lot.

Bought a House

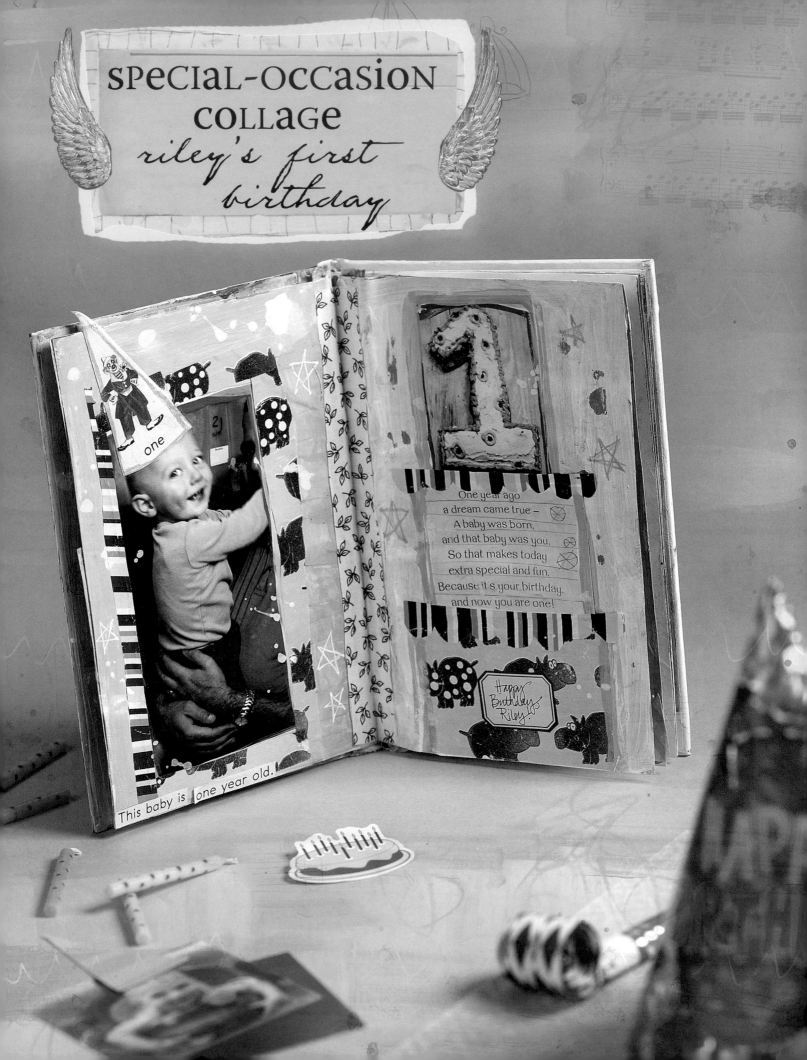

materials

- vintage book
- bulldog clips
- white gesso
- paintbrush
- photographs or printed images
- glue stick
- craft acrylic paint
- water
- paper towels
- scissors
- scraps of wrapping paper from birthday presents
- cut-out sentiment from birthday card
- Golden Artist Colors glazes (Fresco Cream and Aquamarine)
- words/phrases cut out from a vintage book
- water-soluble crayons
- pencil
- Uni-ball Signo white gel pen
- strip of fabric

Since Riley was born, I've been keeping

an ongoing art journal of his life in an altered book I created. When his first birthday arrived, I wanted to create a collage that used significant memorabilia from the day to capture as many memories as possible. I included a photo of the birthday boy, a snapshot of his one-shaped birthday cake, the poem from the birthday card his father and I gave him and bits of wrapping paper from some of his presents.

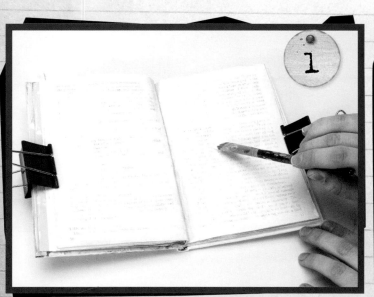

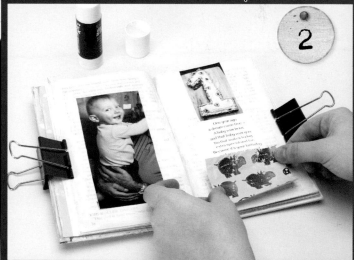

Prepare pages

Take a vintage book, clip the pages open to hold them steady and coat the pages in white gesso to give them some stiffness and tooth. (If you are working with very thin pages, you may want to adhere several pages together with gel medium for added thickness before coating the pages with gesso.) Allow the gesso to dry.

Adhere images

Lay out the images you've selected in the composition of your choice. Use a glue stick to completely cover the entire back surface of each element (especially the corners!) before pressing them into place.

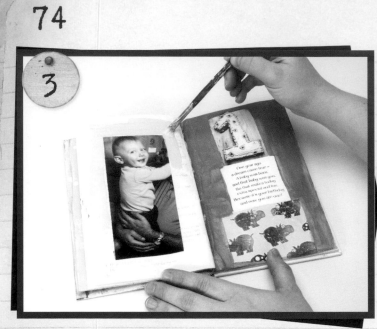

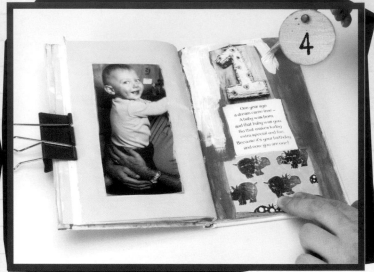

Apply paints

Select a background color and begin painting the surface of the page around the collage items. Here I used gray and green acrylic paints as base colors on opposite sides of the spread. Allow a few moments for the paint to dry, depending on the effect you want to create. Leave the paint a bit wetter if you want the next layer of paint to blend in a bit, or let it dry completely if you want the top layer of paint to stand more on its own.

Layer paints

Experiment with layering different shades of paint until you create a look you like. Once the background colors I chose had been painted, I didn't think the end result looked bright and cheerful enough for a celebratory birthday spread. I added a turquoise blue around the focal photo to accentuate the color of his shirt and a coat of white to the gray to brighten it up a bit. I allowed some of the first coat's colors to remain around the borders of the images.

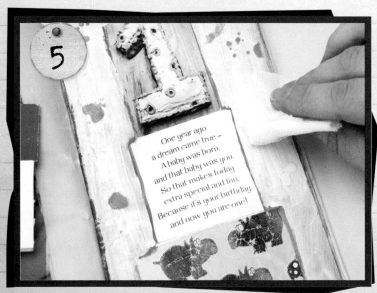

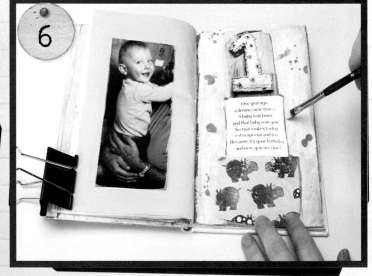

Paint details

Outline the collage elements on the right-hand page with a bit of blue paint to make the page look more unified with the left-hand page.

Splatter with water

Splatter water onto the wet white paint, wait a few minutes while the rest of the paint dries and then blot the water spots with a paper towel to allow the first layer of paint to show through. (See Splattering Paint on page 18 for more on this technique.)

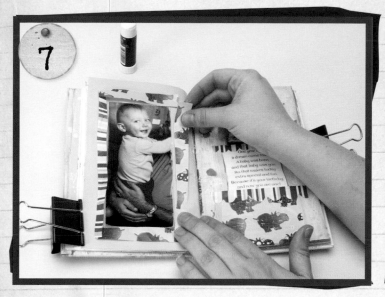

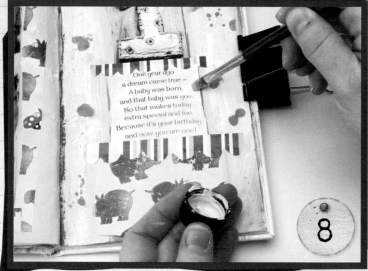

Layer papers

Cut strips of wrapping paper and adhere the paper elements to the collage with a glue stick to deepen the layered effect.

Apply glaze

Brush glaze over the white paper so it is not quite so stark in comparison to the other elements of the collage. Here I used Fresco Cream glaze and then Aquamarine glaze.

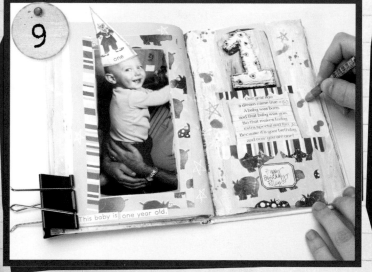

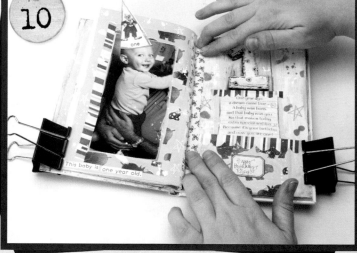

Add additional collage elements

Use a glue stick to adhere a few final collage elements, like words and images cut from vintage books. Using a white gel pen, a pencil and water-soluble crayons, start adding some final details. Here I outlined the image used to create the hat and sketched some stars and other elements on the background.

Add fabric

Splatter white acrylic paint on the background. As a final touch, use a glue stick to adhere a strip of fabric along the center of the spread to cover and reinforce the binding, further unifying the two pages as one work of art.

CHAPTER FOUR
incorporating symbolic
images, photos
and icons

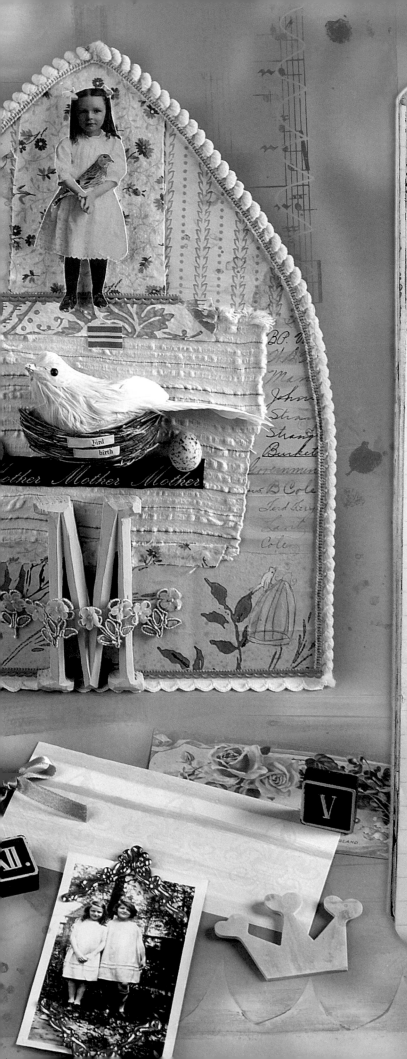

4

Until this point, we've primarily discussed adding your own photos, words and items to personalize your collages, but the process of making your work more meaningful doesn't always have to be so literal. The use of symbolic elements within your art is another way to take your work to a more expressive level. You may not even realize it, but it's likely that you already use many images, shapes and colors that have special meaning to you in your collage.

The saying is true: Artwork really is a window to the soul. Those who view your art feel a personal connection with you, regardless of whether or not you intend them to. You may purposely choose to include symbolic images known only to you in your collages to be thought provoking or mysterious, or you may prefer visual metaphors to portray your thoughts. Or, you may simply clear your mind to start working and see what comes out naturally. Allowing images and themes to reveal themselves through your subconscious without censorship will give you great insight into your personal symbols and will also enhance the way others connect with your work.

In this chapter, we'll examine ways to intentionally include symbolic elements in your art as well as ways to identify symbolism you didn't even know you were using. Soon you'll be achieving new dimension and depth in your personal, expressive collage.

Vintage Photographs

While using modern photos and mementos can tell a personal story in your art, sometimes you may want to create a piece that's more visually universal. Or, you might want to illustrate a specific event and find you don't have a photo or memento available to use. (We've all found ourselves in meaningful situations without our cameras!) Symbolic artwork is a great way to illustrate these moments in a uniquely creative manner. In artwork, the most obvious way to begin experimenting with symbolism is to purposely use images or items to represent something else.

I often use old photographs to represent myself and my loved ones in my pieces. Most collage artists use vintage photographs in their art to give it a classic flavor, so if you are one of them, this is just a new way to approach something you're already doing. Instead of choosing appealing images at random, you can carefully select representative photos to help tell your own story.

Over the years, I've amassed quite a collection of vintage photos (and I'll talk more about how you can build your own collection later in this chapter), but there are certain images I use over and over in my artwork. These (at right) are photos of girls who remind me of myself when I was young. As you can see in my own childhood photo (below), I was a very reserved, shy child, and I've collected several photos of girls who have that timid feel about them. In addition, I had dark hair, so you'll very rarely see a girl with light hair in my artwork. Many of the photos really do look like me as a child, and others just capture the essence of a quiet, scared girl. Any time I do a piece about something personal and don't want to use a literal photo of myself, I choose one of these instead.

78

In *Lookout* (below), I've used two old photos to represent parts of myself. I created the bird-girl at the top with one of my self-representative old photos (using the extended photo technique from page 40), not quite knowing where it would lead. I then continued at the bottom of the piece with another representative vintage photo placed beneath the canopy of a tree. When I was finished, the bird-girl seemed to have a wisdom about her. I felt as though she was a protector, perhaps protecting the girl in the bottom portion of the piece. I chose the word "lookout" as my final embellishment. In the end, I believe the piece represents a part of myself that focuses on self-protection.

lookout.

Lookout

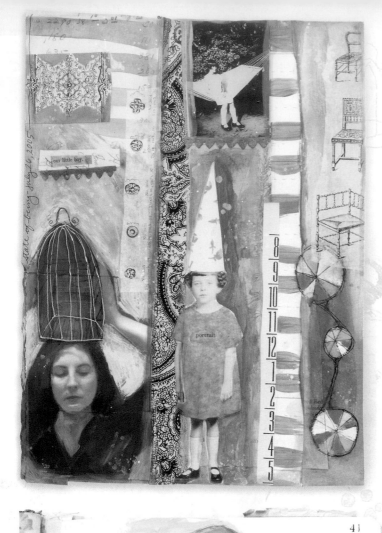

Using these images to represent yourself is akin to including self portraits in your art. You will find that even if you gravitate toward the same photos over and over again, the images will take on a different personality each time they're used. For example, let's consider three different pieces in which I've used the same photo of a girl. She represents me in each piece, yet the pieces don't seem repetitive. In *Portrait* (at left), she was simply used as an illustration for my state of being that day. In *Restraint* (bottom left), her body was caged to illustrate the way I felt when I was newly pregnant with my second son. And in *Motherhood Doll* (below), she took a different form entirely.

Of course, you can also use vintage photos to symbolize other important people in your life. With my new foray into motherhood, I've also begun using lots of "baby" and "little boy" photos to represent my children, as well as photos of mothers and their children. This was especially useful

Portrait (at left); Restraint (bottom left);
Motherhood Doll (below)

during my pregnancies since I did not have actual images of the babies I wanted to represent visually in my work. For instance, in the piece shown on page 13 from my second son's pregnancy journal, I used a photo of two siblings. At the time I did the piece, I did not know whether the new baby would be a boy or a girl, so I tried to choose a photo in which the younger child could be perceived as either. This piece of art expressed my uncertainty about handling two children so close in age, and since this photo portrayed two children with about the same age difference that mine would have, it served as a good visual representation.

In *Day with Potential* (at right), I used vintage photos to illustrate three different themes. There was a day a couple years ago in which three different life-changing events could have occurred in our family. We placed a bid on a house, my husband expected to hear about a job he had interviewed for and I took a pregnancy test. In the end, the only thing that came through was the house, but this collage illustrates all of that day's possibilities. For all three subjects, I carefully selected vintage photos: a photo of a house, a photo of a ma, and a photo of a baby.

The possibilities are endless. When doing a piece about your vacation, maybe you find yourself wishing you had taken your camera along on that fishing trip—but now you find a vintage photo of a couple on a dock holding up the day's catches and decide to use that instead. Maybe you want to do an anniversary collage as a gift for your parents, but they always protest having their picture taken—opt for a vintage photo of a sweet elderly couple on a park bench.

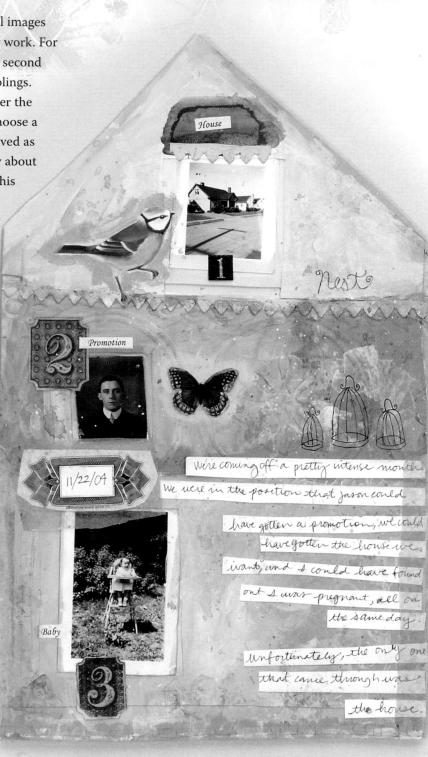

Day with Potential

When specifically selected to symbolize people or events, vintage photos immediately become less ambiguous and more meaningful. If you haven't been using representative old photos, why not begin a collection? There are many places to go about hunting for such photos. Check the Internet for listings of postcard and photo shows in your area. At these events, you can flip through hundreds, even thousands, of photos all at one time. Antique stores are also good sources of vintage images, though they can sometimes be pricey. If you're hunting for more of a bargain, you can try your luck at estate and garage sales. My favorite photo source is eBay, which has auction listings for thousands of vintage photos at any given time. It takes some time to look through everything, but this is where I've found most of my favorites. If you decide to try this method, try refining your search with descriptive words to pinpoint exactly the subject matter you are searching for in these old images.

If you are a collage artist who already uses vintage photos in your work, consider whether or not you may already subconsciously be using this technique. Maybe you have certain old photos you use over and over. What is it about that photo of the little boy in suspenders and a hat that resonates so strongly with you? Do you like the photo simply because he's cute, or might he remind you of someone you love? Bringing a little more awareness to the use of vintage photographs in your artwork can almost immediately make it more personal to you and your story.

Other Representative Images

Along the same lines as the use of vintage photos in your collages is the use of other representative, nonphotographic images. There's no rule that when you're trying to represent a loved one in your work, you have to use a photo of a person to do so. In our minds, we all make associations between things and people, whether we realize it or not. If we can learn to draw upon those associations and use them in our artwork, we can add meaning in new, interesting ways. For example, you've probably noticed my frequent use of bird-related ephemera in my work. Birds, nests, birdcages and eggs have all become very symbolic for me. Given the most prevalent themes in my work, you can probably guess that they've come to represent motherhood and "nesting," among other things.

I also use paper dolls frequently, especially a few little boy dolls (and clothes) that I use to represent my son in my artwork. The page shown on page 32 from Riley's baby journal features a paper-doll outfit as the main subject. The opposite page in the journal uses sepia images, so I chose this outfit because of the brown tones, but also because it spoke to me in a way that represented his sweetness.

Another image I use to represent Riley is a rabbit. I've found that all vintage flash cards seem to show a rabbit image on the "R" card, and thus this association began transferring to my own work. (In fact, I've begun collecting vintage toy rabbits for him as well.) In these two detail shots of *I Had a Rabbit*, an oblong foamcore collage I created to express my emotions about becoming a mother of two (at right), you can see I've made several references to rabbits. I cut some sentences from a vintage book reading, "I had a rabbit. A little white rabbit." I then also included an image of a rabbit and a pictogram-style phrase that says, "one rabbit, two rabbits." The representation is clear if you have knowledge of my personal symbols, but to the average person, it is more ambiguous.

There are no hard and fast rules when it comes to incorporating personal symbols into your work. All you need to do is pinpoint images that you personally associate with something or someone. They can be obvious (a car to symbolize your brother, the car fanatic; a tree to represent your grandfather, the gardener) or more obscure (the number 2 to represent your second daughter; a peaceful field of wildflowers to represent your best friend and confidant).

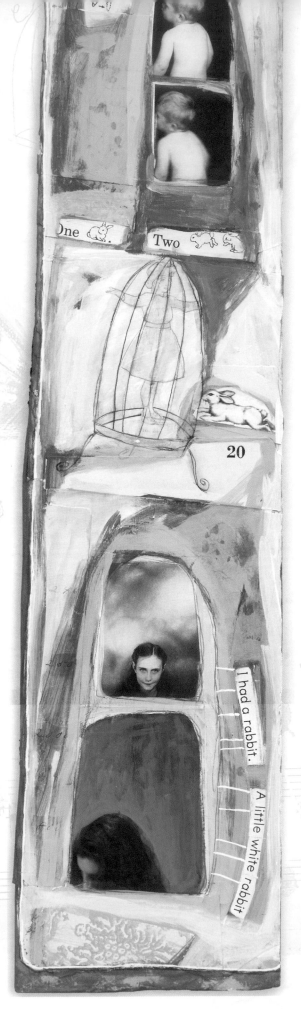

I Had a Rabbit

You probably already make associations like these in your mind, and now it's just a matter of using them in your artwork. Even if the meaning of the resulting collage is known only to you, you may find that this frees you to be even more honest and less self-conscious in your work.

Finding Your Existing Symbols

So, now that you have some ideas about intentionally using symbolic images in your artwork, let's take that idea a step further and start looking for unintentional ones. These are images or colors or shapes that tend to surface repeatedly in your work, perhaps unbenownst to you or without you having a full understanding of their meaning. You may already have a symbolic vocabulary that is just waiting to be tapped into consciously in your art.

One of the most important things I learned in my training as an art therapist is this: Nothing in art is an accident. When we create art, we choose our themes, our subject matter, our images, our colors—everything—for a reason. The subconscious mind is extremely powerful, and art is one of its vehicles for revealing things to us. We might have internal censors monitoring the things we write or say, or even the things we think, but chances are those censors neglect to monitor our art, since it's not a medium we're as used to "speaking" with. As a result, lots of little clues about ourselves emerge when we create. It's our job to try to interpret these clues.

In this section, I will show you some exercises that will help you begin to find and interpret your personal symbols. You may experience a breakthrough and see something that has been hidden from you for years, or you may find the ensuing journey to be a slow, gradual process in which things are revealed bit by bit. Regardless of the magnitude of your revelations, I guarantee you will gain some insight into your self and surprise yourself with some of your discoveries. You'll learn to listen to your artwork when it speaks to you.

I see this sort of thing happen repeatedly with my own work—unintended meaning revealed to me long after a piece is completed. The most amazing instance of this I've experienced is with *Procession, Suspension*, a piece

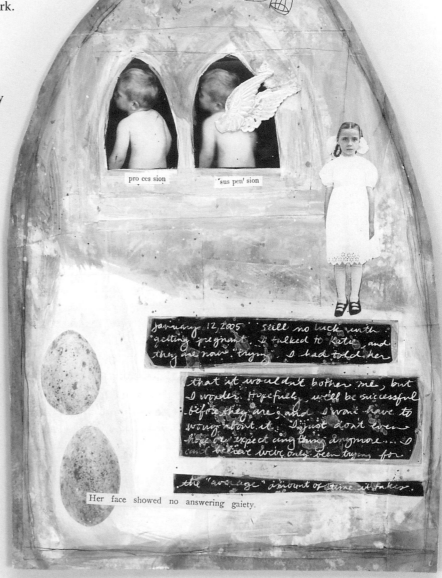

Procession, Suspension

of art (above) I did while trying to become pregnant for the first time. Months after completing the piece (and after I had become pregnant), I noticed the date on this particular piece fell very close to the date of my son's conception. I suddenly was interested to see what images and journaling I had used that day, having not realized that I was about to be (or perhaps already was) pregnant.

The piece shows two similar photos of little boys, two eggs and two birdcage drawings. What's unusual about this is that, at the time, I rarely used photos of little boys (I've wanted daughters ever since I can remember!), and I also rarely used images in twos, since we were hoping

our family would soon be three. For my journaling, I had written about speaking with my sister and learning that she was also trying to become pregnant. While the images I had used in this piece were distinctive enough, this is where it becomes really amazing. You see, on the same day I conceived my son, my sister conceived hers! Two eggs, two birdcages, two boys.

Coincidence? Maybe. Or maybe my subconscious mind was so in tune to my body and to my loved ones that it emerged in the artwork I did. Regardless, even if it is coincidence, it's a pretty amazing coincidence. And I prefer to believe, once again, that nothing in art is an accident.

Myself (below) also shows my subconscious mind at work in mysterious ways. I didn't have anything in mind when I worked on this piece, but when I was finished, I realized it had become a sort of family portrait. The main image is one of the vintage photos I use to represent myself, and behind that image is a negative of myself as a young girl. When I examined the piece after I was finished, I saw some interesting things. I had used three stars and five architectural images as accents. In my immediate family, there are three daughters, five members in all. I had painted lines between four of the architectural drawings and the self-image. The top architectural image is not connected.

While I have good relationships with everyone in my family, my father and I have the least in common, which appears to be evident in this piece of art.

Every piece of art you do is not going to create mind-blowing revelations, obviously. I've done hundreds of pieces of art, and these are two of my most poignant examples. However, once you begin looking more closely at your art—and with the assistance of the following exercises—you will start seeing things you may not have seen before.

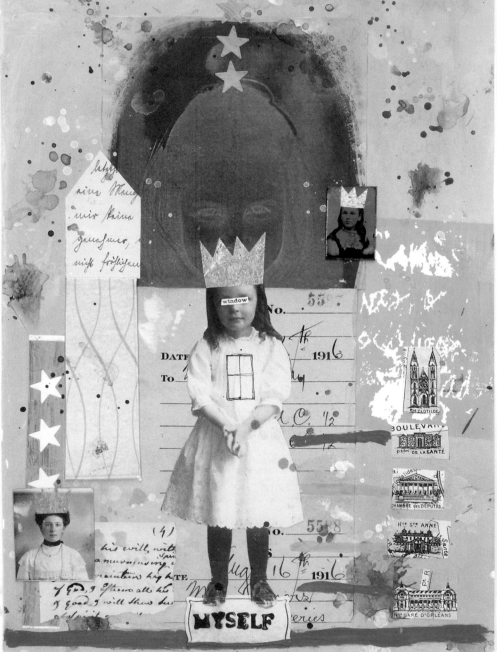

Myself

EXERCISE: Revealing Subconscious Associations

This is a four-part exercise that will start you on the road to self-discovery with your artwork. It's best to do this in a place where you won't be interrupted. You will need a partner for the first step; a partner is optional for each additional step. Each part of this exercise can be done at different times (with breaks in between, if you wish), but the steps do need to be performed in order.

STEP ONE: Choose a medium that is available in a variety of colors and will allow you to create different effects by using varying amounts of pressure. I used water-soluble crayons here. Pastels or another type of crayon would work too. (Just avoid using something like marker, since it doesn't allow you to alter your strokes as easily.) Gather your drawing materials, as well as a fairly large piece of paper. You'll need room to fully illustrate each word side by side.

Give your partner the word list shown here, and have him read a word aloud every forty-five seconds. Ask him to read them out of order, so you can't anticipate which will come next. As you hear each word, use your drawing instruments to express your initial response on the paper. Try not to think too much about what you're drawing: You can draw abstract shapes, literal objects or even scribbles in colors that speak to you. The main point is to illustrate what you think each word "looks" like without taking too much time to analyze it. Remember: You have only forty-five seconds per drawing.

The results of my attempt at this exercise are shown here. Don't think yours needs to be done in a similar style; this was just my own interpretation of the exercise. You could interpret it completely differently.

word list

sadness nurturing

happiness anger

hurt excitement

despair shame

love obligation hate

resentment resignation

STEP TWO: Take a few minutes to look at your drawings. What observations and comparisons immediately come to mind? Do you see similarities between any of the illustrations? Have you used similar colors or lines for any of the words? Maybe three of your illustrations all use green and pink or have crosshatch marks. Maybe you've used stars for several emotions. Do the graphics for any words stand out to you as noticeably different from the others? Maybe all your drawings are delicate except for one bold one. Does anything surprise you? Maybe you didn't expect the word "shame" to look this way. What could these things mean?

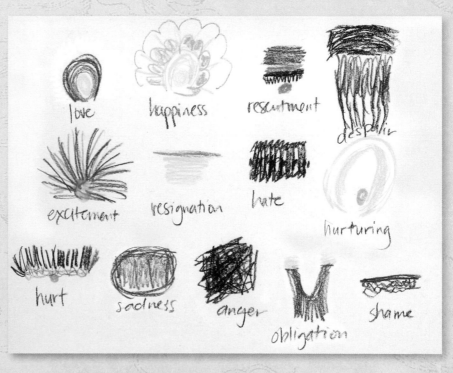

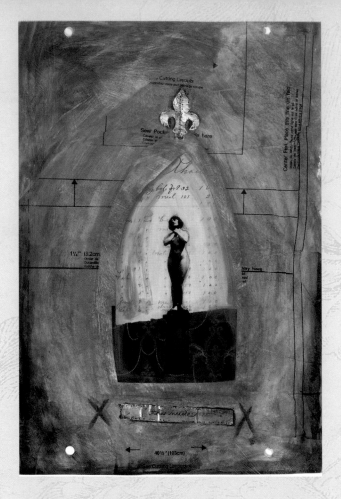

Once you have spent some time examining your work, you might find an outside perspective interesting. Consider asking your partner to look at your drawings and point out any observations. Perhaps she will notice a pattern or an association that is so subconsciously natural to you it escaped your own observation.

In analyzing my own exercise, I immediately noticed strong similarities between a few of my words. My renditions of "hate" and "anger" are similar. At the opposite end of the emotional spectrum, my renditions of "love," "happiness" and "nurturing" contain similar "enclosing" sorts of shapes, as well as some of the same colors.

These associations may seem fairly basic. It's only natural to make a connection between hate and anger or between love and happiness. But none of the connections you make, however obvious,

are insignificant. Looking further, something that surprises me a bit is that my drawing for "obligation" features a similar enclosing shape—but it's been turned upside down. This connection may be far more revealing. Could it be that a part of me finds love and happiness and nurturing to be obligations?

Look for less obvious connections in your own drawings. Do you see similarities between "love" and "hurt"? Or "sadness" and "nurturing"? Or "anger" and "excitement"? If you do, don't jump to conclusions. Just make note of and begin to think about these observations. In the next part of the exercise, we will apply some of the knowledge we gain in this step directly to our collages.

STEP THREE: Choose between five and fifteen pieces of your artwork to examine closely. I've chosen ten to work with (all shown on this spread). Try to choose art that is similar in style—all collage work, for example—and from the same time frame—say, within a year. Comparing pieces that are too innately different from one another will just make it more difficult to find the symbols you'll be looking for. And, if possible, the more personal the artwork you choose, the better.

Lay the pieces out so you can see them all at once. Then lay your drawings from Step One alongside them. Look for similarities between the images and colors you used in your drawings and those you use in your artwork. Do colors that are prominent in many of your pieces match colors from any of your emotion illustrations? Maybe you used red to illustrate excitement and you see that red is the most common color in your artwork. Can you see shapes or lines that repeatedly emerge in similar forms? Maybe you used a spiral shape in your drawing of a particular emotion that you now see repeated in a lot of your artwork. What could these things mean? Again, if you wish, ask your partner to look for additional insights.

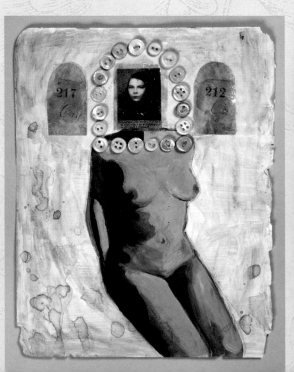

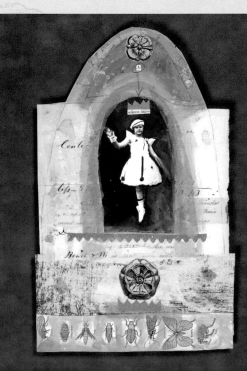

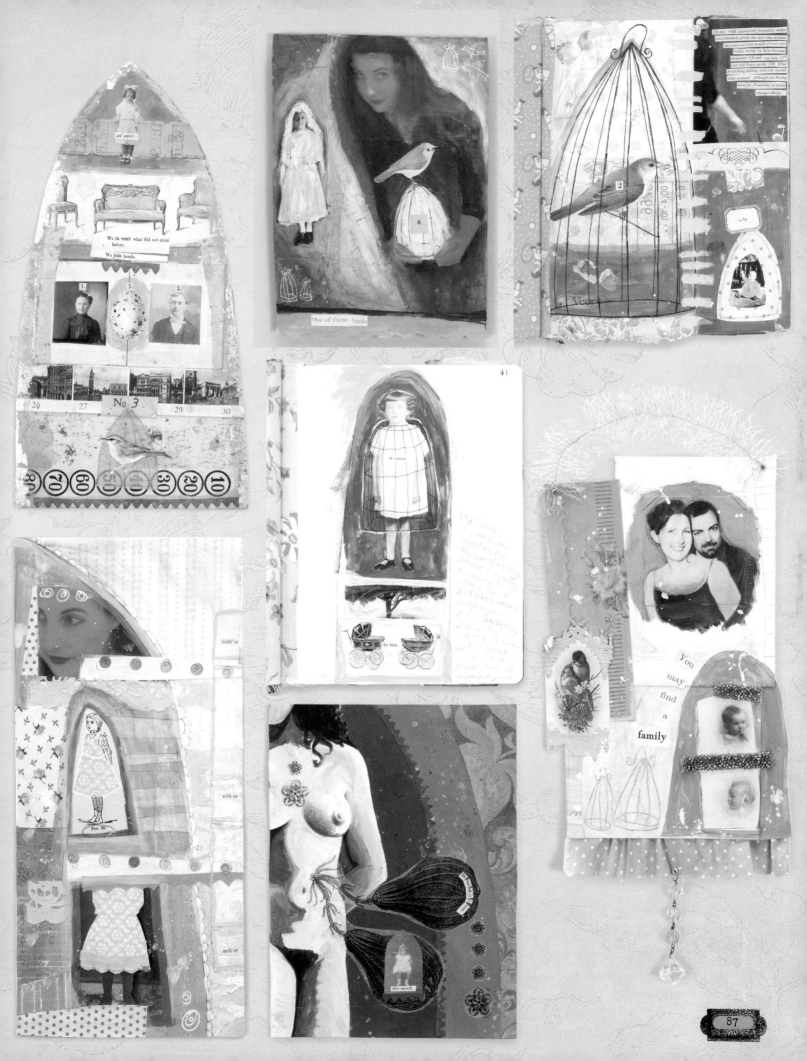

Consider your findings from Step Two. Do any of those observations suddenly make sense now that you are looking at your work itself? Perhaps you used the same colors for the words "love" and "hate," and now you see you've also used those colors in pieces about your ex-husband.

I know all this might sound ambiguous and confusing. There are a lot of "what ifs" and "maybes." There are no black-and-white answers. The questions are meant to open you up to the possibility that your subconscious mind is speaking through your artwork.

In looking at the pieces I selected, one of the first things I notice is how often I use arches and enclosing shapes. I see some form of this shape in every piece I've chosen—just like in my illustrations for love, happiness and nurturing.

So what can I learn from this discovery? Well, I already know how important feeling nurtured is to me. In general, I'm an insecure person, and I need constant reassurance from those who are important to me in order to feel loved and happy. Additionally, as you know, my past few years have been a time of pregnancy attempts and new motherhood, further reinforcing those themes.

But how does this tie into my art? For as long as I have done this style of artwork, I have felt drawn to shrines and arches and womblike shapes. Something about them strikes a deep chord within me, and they feel extremely right. Until I first did this exercise a few years ago, I didn't realize how prevalent these shapes were in my work, or what their meaning was. But when I did this exercise, it immediately made sense that I would find such resonance with this shape that I subconsciusly seemed to associate with nurturing.

Now that I understand these connections, I am able to pay closer attention to them when they appear in my artwork. One newer revelation to me is my use of an inverted arch shape in illustrating "obligation." But it seems to make sense. Although obligation might have a seemingly negative connotation, and love, happiness and nurturing might seem more positive, with my new role as mother, much of my life has come to involve a combination of these things. So it is probably natural that I would feel a sense of obligation

tied into my feelings of love, happiness and nurturing. Perhaps the inverted shape indicates that it's an emotion on the flip side of the others, though still connected.

This is all about looking at your artwork and within yourself and making your own connections. Maybe you also use enclosing shapes, but to you they symbolize quite the opposite of my own assocation. Instead of being safe and womblike, maybe they feel constraining and restricting. And don't worry if you couldn't find anything that seemed significant to you in this part of the exercise. Once you open your mind to be receptive to these symbols when they arise, you likely will begin to make discoveries in your future work.

STEP FOUR: Set aside your emotion drawings, and focus now solely on the complete works you chose for Step Three. Take a moment and sit with them. Allow their mood and essence to reach you. If you'd like, have your partner do the same. After a few minutes, think about the sort of emotion your artwork exudes. If you had to choose a few words to describe the collection, what would they be? Is your work joyful, vibrant and excited? Or is it sweet, gentle and timid? Looking again at my own group, some words that come to mind are still, soulful and within. (I know that "within" isn't an adjective, but I get a sense of introspection and looking within when I examine my art.) When I asked my husband for some words, he gave me nurturing, comforting and reassuring. If you involved your partner in this exercise, what words did he or she use? Were they a pretty close match to your own, or were they quite different? Maybe you feel your work is whimsical and light, but your partner described it as dark. What could this mean?

As an artist, you're probably so used to concentrating on one piece of your work at a time that seeing a whole group may give you a different perspective on what your art is saying. For instance, I hadn't realized how "still" and quiet my art seems to me, even though my pieces have a lot going on visually. I was also surprised by the words my husband chose. Whereas I view my art to be more about myself and my own thoughts and feelings, he views it as more about my relationships with others.

Next, take another look at your work and see if you notice any repetitive images or themes. These may be obvious or more subtle. Do the majority of your pieces have something to do with lost love? Do several of them feature images of children? Do you tend to use

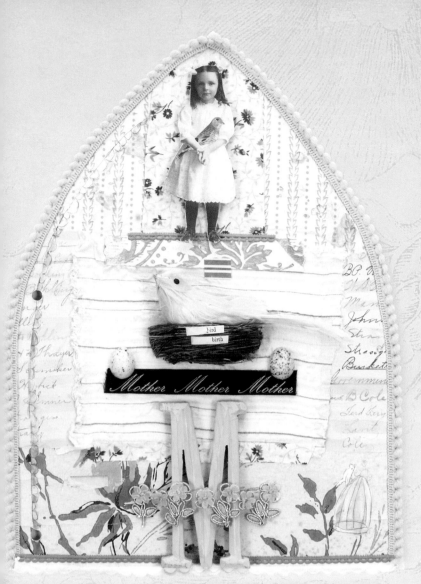

Bird, Birth

to me, and the birdcage became another version of this womblike icon. By extension, I began using birds and nests and eggs as well. In the last couple years, as I have become immersed in all aspects of motherhood, these images have become even more dominant in my work. Eggs often represent the babies I've carried, nests often represent the womb and nurturance, and birds often represent me as the mother bird. Once you have identified your personal symbols, begin exploring ways to use them intentionally in your artwork to create more powerful illustrations of your emotions or themes. In *Bird, Birth* (at left), I've intentionally used several bird-related images to relate to my motherhood theme. The top image shows a girl (a vintage photo chosen to represent me) holding a bird (a symbol chosen to represent a child). Then in the center of the piece, there is a nest with a bird inside and the words: "bird, birth." Underneath the nest are two eggs, which stand for my two babies. There's a drawing of a birdcage in the bottom corner, and the word "mother" is repeated.

Again, I'm not saying that if you also use bird-related images, they must represent nurturing and motherhood. This is just my interpretation of my work. Every artist has her own symbols. And all this insight did not come to me overnight. I constantly am questioning my art—and myself—to understand what may be revealing itself in my work. The first time I did the emotion drawings exercise was a few years ago, and as time passed the associations I made were not immediate but gradual, with time and thought. The process of exploring and learning to understand your symbols in your art truly can be infinite.

The more you examine your work, the more you can learn about yourself. Just don't take these exercises too literally. I've certainly done artwork with images that didn't have deeper meaning (that I know of, anyway!). There aren't any rules here. Every piece of work doesn't have to be a beautiful visual metaphor. Every time you use the number 2 it won't necessarily represent "two children." Every time you use a tree image, it won't necessarily mean you are looking for growth. Every time you draw a circle, it won't signify that you feel fulfilled. But recognizing your symbols is undeniably a big step in the direction of making your art more personal, more a reflection of you.

multiples of four frequently? What are the threads that run throughout your work? You may not have noticed how often you use flower images, but when you see several pieces together, the blooms seem to jump out at you again and again. What could that mean?

The ongoing challenge is to interpret your findings. Only you know the significance of these things. Maybe you use wings frequently in your work. What kind of wings are they? Bird wings, butterfly wings, angel wings? Do they signify the desire for freedom? Or the desire for escape? Is their connotation positive or negative? Would you like to have wings? Why? These are the sort of questions to ask yourself when you think you have identified a theme in your art.

I've already mentioned the bird-related imagery prevalent in my work. I began using this sort of imagery a few years ago because I was drawn to the birdcage shape. As you know, enclosing, arched shapes have great meaning

EXERCISE: Exploring Your Work Piece by Piece

This is a much shorter exercise that may give you further insight into a particular theme or piece of artwork. It can be done by yourself, but as with the previous exercise, it's helpful to have someone else also do it with you for a different perspective.

Take a single piece of artwork you would like to explore and lay it out. Choose one of the subjects in the piece to focus on. It doesn't have to be the main subject, but it should be an actual "subject" (rather than an insignificant background color or texture, for example). Below is a list of unfinished phrases. Finish these phrases in the voice of your chosen subject. If you chose something other than a person, just personify the item and speak as if it could speak. Try not to think too much as you're doing this exercise. Just write the first thing that comes to mind. And remember, you're speaking as if you are that subject, not as yourself. If you have a partner, have her do the same for the same subject.

```
I am ...
I will ...
I wish ...
I won't ...
I want ...
I fear ...
```

The piece for which I did the exercise is shown in full on page 80, but the areas I chose for this exercise are shown here in further detail. I first chose to focus on the image of myself in the lower left-hand corner (though I just as easily could have chosen the girl in the hammock, or the girl wearing the hat, or one of the chairs, or even the birdcage). Here is how I completed the phrases:

```
I am balancing the birdcage on my head.
I will hold it tightly.
I wish there was something inside.
I won't let it fall.
I want to be able to set
   it down for a while.
I fear that I won't be able
   to hold it for much longer.
```

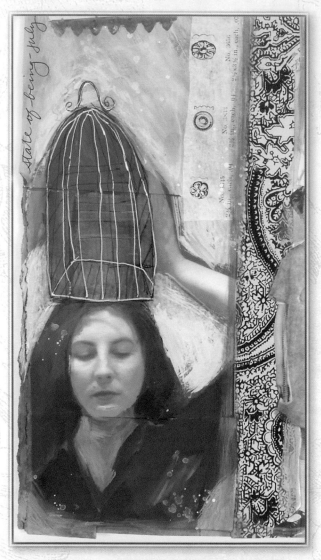

After you've done this for one subject, try doing it for another on the same piece. This time I will focus on the girl in the hammock.

> I am looking at you.
> I will keep sitting here.
> I wish there was someone with me.
> I won't rock in the hammock.
> I want to rock, but I need
> to keep watching you.
> I fear taking my eyes
> off you and relaxing.

Okay, so what was the purpose of all that? Well, to some degree, all of our art is a form of self-portraiture. We are visually expressing ourselves when we create, and our souls and personalities shine through. Each piece in a collage can be viewed as a portrait of ourselves (even if it's not a literal portrait, as my first subject was), and this exercise taps into that. Read back over your responses, keeping in mind that in some sense, it is you saying these things *through* your subject. Does it give you any insight? Do any of your responses take on different meaning than you originally intended the piece to have (if you originally had an intended meaning at all)? It's important to do this exercise for different subjects within the same piece because these elements may represent different parts of your self. How do the two subjects interact? If you had a partner do this with you, did she read your art differently than you did? As with the last exercise, someone else's responses may give you extra insight.

In my case, here is what I take away from this experiment: This piece was done during the later stages of pregnancy with my first son, and I currently am in the late stages of pregnancy with my second. The reason I note this is that my responses now probably have a lot to do with my current situation and where my mind currently is focused, but they also could have applied at the time I created the piece.

As you can see, the statements I made about the first subject have to do with holding on to this birdcage while struggling between the desire to set it down and the need to keep holding it. Again, birdcages are protective, nurturing environments to me, and I think that in this case, the birdcage represents my nurturing skills. Right now in my life, I've got a lot going on. We are in the middle of a cross-country move, I am pregnant and I am taking care of Riley, who is a little more than one year old. I'm struggling with feeling like I can handle it all, especially with trying to assure myself that I can be a good mother to both boys once the second one is born. So keeping a handle on this "birdcage" is an effort, to say the least.

My statements in the voice of the second subject were very interesting to me. As I looked at this girl in the hammock, what struck me was how rigid and still she is, and how her eyes just stare into me. I couldn't get past her eyes watching me. She's not having a good time on the hammock, and she seems to be there for a purpose. As I completed the statements, I got the feeling that she was supposed to be watching me. What I take away from this is that here is a vigilant part of myself, insisting that I stay strong and handle everything.

This exercise can be quite revealing, can't it? Don't put a lot of pressure on yourself to always read significant meaning into your own responses. When a piece is about to yield a particularly fruitful insight (and it's worth noting that they all certainly won't), it needs to do so naturally—trying to force it will just be counterproductive.

This would be a good exercise to use in further exploring one of the personal themes you may have identified in the previous exercise. For instance, if you noticed that you tend to use images of angels frequently, perform this exercise in the voice of one of these angels in a favorite piece and see what may be revealed. Again, the more you start looking at and creating your art this way, the more you will be able to read it and understand it.

A lot has been covered in this chapter, from purposely using symbolic images to represent things in your life to probing your subconscious to discover symbols you might not even know you are using. It's a broad spectrum, and you can push yourself to whatever point on the spectrum you feel comfortable with. Even if you aren't actively trying to use or uncover personal symbols, just having read through this chapter will probably make you more aware as you are creating, which will lead to more meaningful artwork. It's an ongoing process starting you on the road to self-discovery with your art.

materials

- 2" x 4" (5cm x 10cm) block of wood cut to 13" (33cm) long
- 7 strips of different patterned scrapbook papers or vintage wallpapers
- decoupage medium
- paintbrush
- acrylic paint
- scissors
- glue stick
- tissue paper
- collage images and words
- Golden Artist Colors glaze (Yellow Ochre)
- wire cutters
- spool of thin craft wire
- heavy-duty all-purpose cement adhesive
- 6" (15cm) ball chain
- beeswax
- 2 ceramic doll heads
- hammer
- nails
- 14" (36cm) ribbon

I did this piece of art when I found out

about our sudden cross-country move. Although this was a good move for us, I was experiencing apprehension about the preparations that needed to be made as well as the ultimate life change it would mean. I had the image of a dangling birdcage in my head, sort of hanging there, not terribly stable, but at the same time protective of the occupant. For this image, I wanted a tall, narrow base, so I chose this block of wood. The girl who occupies the cage has a slightly worried look on her face, so I chose her to represent me.

I decided to use the image of the little girl on the right in this vintage photo to represent myself. Not only does she look a bit like I did when I was a child, but the expression on her face seemed appropriate for this piece.

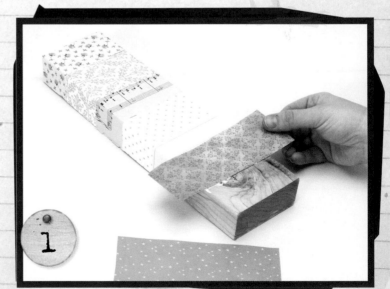

Adhere papers

Cut strips of decorative papers and adhere them onto the front, sides, top and bottom of the block using decoupage medium applied directly to the wood.

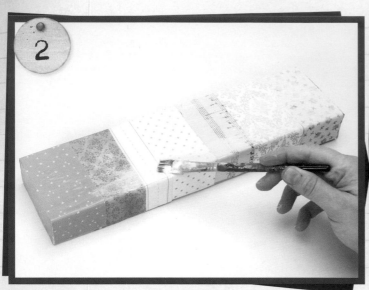

Apply paint to mute colors

Brush a translucent or watered-down off-white acrylic paint over the patterned paper on all six sides. Allow a few minutes of drying time.

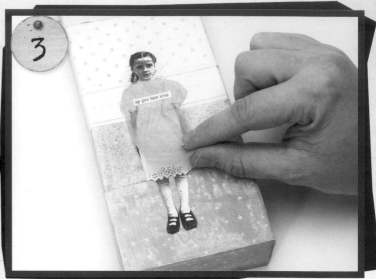

Adhere collage elements

Cut out the collage image of your choice and use a glue stick to position it on the front of the board. Here I used a photo of a little girl. I then cut out a tissue-paper dress, which I layered on top of her image with a glue stick, and glued the word "apprehensive" on her dress to complete the main subject of my collage.

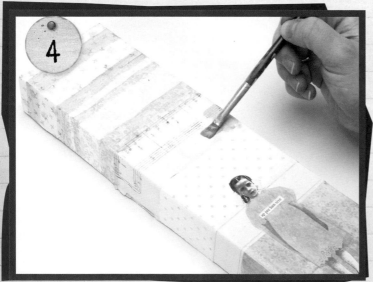

Layer paint

Paint random stripes with the Yellow Ochre glaze to balance the color of the tissue-paper dress. To finish, splatter white acrylic paint over the surface of the collage.

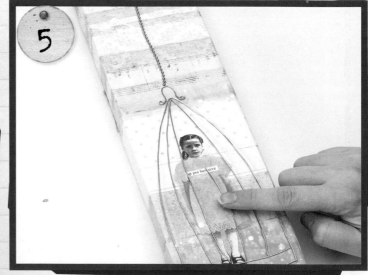

Apply wire

Use a wire cutter to cut pieces of wire and begin to form the shape of a birdcage around the girl. Use a heavy-duty cement to adhere the pieces of metal to the collage surface. Lay a length of ball chain from the top of the cage to the top of the block and cement that into place as well.

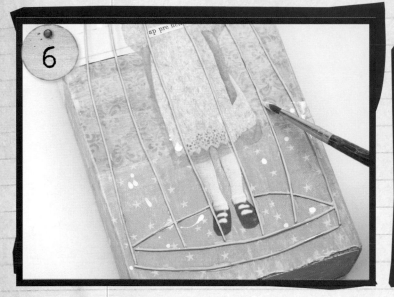

Paint wire

Using a small detail paintbrush and blue acrylic paint, very carefully paint all the metal wires and chains. (Another option would be to buy wire in the color you want so you can skip this step.)

Attach ceramic figures

Stand the block of wood up on its end so the front of the collage is facing you. Melt some beeswax on the stove, in a mini pot for heating potpourri or in a specially designed melting product. Dip the bottom of each ceramic head into the wax, and adhere them to the top edge of the board. Then use a paintbrush to drip melted wax around the heads, letting the excess drip down the front and sides of the collage.

Attach ribbon

Hammer a nail into each side of the board about ¼" (6mm) from the top. Tie an end of the ribbon onto each nail to create a hanger for the piece.

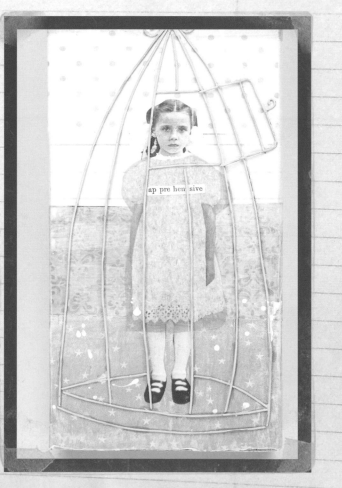

5

weariness.
e la tion

sweet
sweet

child
child

projects

Now that I've shared my secrets, let's look at some intensive collage projects incorporating the various techniques and ideas you've learned throughout the book. The step-by-step projects at the end of the previous chapters were tailored specifically to those themes. The following projects are more comprehensive, creative examples of how you might apply any number of the techniques you've learned to one more complex piece. At the beginning of each project, you'll find a list of all the main techniques used to help you identify them in action.

With each project using different substrates and materials—but with every piece illustrating meaningful imagery and themes—you'll see a clear, step-by-step illustration of how versatile personal collage can be. Of course, I don't expect you to duplicate these projects exactly. Even if you could (which would be virtually impossible without the same personal photos and memorabilia), why would you want to? By now, you have learned how to use your own imagery to create art that is personal and meaningful to you. By seeing my process—from initial inspiration to technical execution—as I create these pieces, you're sure to formulate new ideas for your own work. Sure, when you're getting started, you might want to start by using the same basic composition or materials I've outlined here, and that's natural. But be sure to make the art personal to you. Once you're expressing yourself freely in your collage, you'll find the ideas come more easily.

If you achieve this in your artwork, I'll feel I've done my job with this book. It gets a little boring seeing similar artwork everywhere. Really, how many cute little girls with the word "believe" can you see before they stop evoking an emotional response? When everyone and their sister is creating collage in the same styles and using the same techniques, the meaning of the work is diminished. The main reason there's so much of the same out there is that artists aren't reaching inside themselves when they create. If we each did art that had meaning to us personally, nobody's art would look like anyone else's—and wouldn't that be refreshing? I truly hope the ideas presented in this book will help you on that journey. Good luck, and I'd love to hear how it goes!

COLLAGE ON CORRUGATED CARDBOARD
my sweet little bird

My

little
b I R d

baby boy

Featured Techniques

※ Incorporating symbolism
※ Using words and phrases
※ Using mementos
※ Using a modern photo
※ Framing a photo
※ Covering a photo's background
※ Splattering paint
※ Glazing

materials

- 11" x 14" (28cm x 36cm) piece of corrugated cardboard, cut into an arch shape
- paintbrush
- white gesso
- glue stick
- patterned papers
- scissors
- digital photo printed in sepia tone
- collage images
- sewing machine (or needle if sewing by hand)
- thread in a coordinating color
- acrylic paint
- water to thin paints (optional)
- tacky glue
- miniature nest from craft store
- miniature egg from craft store
- variety of letters (vintage game pieces and a scrapbooking embroidered ribbon letter are shown here)
- foam or rubber letter stamps
- pencil
- Golden Artist Colors glazes (Yellow Ochre and Aquamarine)
- water-soluble crayons
- white gel pen

I took part in a collaborative project

with two other artists. The theme was "motherhood," and my contribution was a "book" made from corrugated cardboard pages tied together with ribbons. Each artist did two pages in the book, and this was one of mine.

I had my son's handprints and wanted to incorporate them into a piece of art, so this was the perfect venue. The pages I created were in an arch shape, so I decided to mimic that shape and create birdcages around the handprints and a photo of him. Inside each cage is also a bird.

Prepare collage surface

Use a paintbrush to coat the front of the corrugated cardboard with white gesso.

Arrange collage elements

Lay out the main images and patterned papers to start determining the basic composition for the piece. When you're satisfied with the positioning, adhere any background elements with a glue stick, but be sure to leave the main elements free. (We will feed these papers through a sewing machine or sew them by hand in step 4.) Here I left the handprints and the baby photo free.

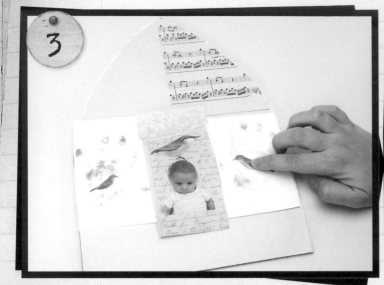

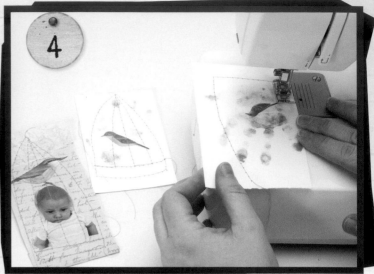

Add secondary layer

Position secondary collage elements onto your main collage subjects to begin to add depth to the piece. Here I glued some small bird images onto the handprints and used a vintage handwritten page to cover the background of the baby photo.

Add stitched details

Using a sewing machine or a needle and thread, sew the outline of a birdcage onto each of the main subjects of the collage. (If you're sewing with a machine, make sure the stitches aren't too tiny, so as not to tear the paper.)

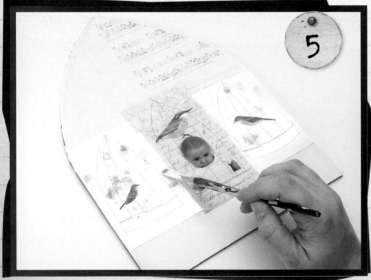

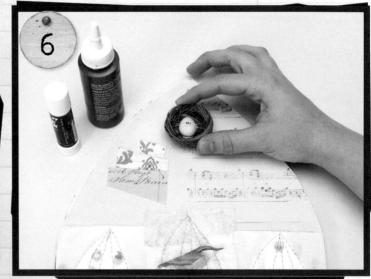

Assemble collage

Glue the main elements onto the collage with a glue stick. Then brush translucent or watered-down off-white acrylic paint over the entire background of the collage—as well as the areas around the handprint birdcages—to give it an aged, muted feel. Finish this step by brushing a translucent or watered-down white acrylic paint on the surface of the center focal element, coating everything but the baby photo itself to tone down the handwriting background and make the image stand out.

Add embellishments

Start adding additional embellishments, using tacky glue to adhere the three-dimensional elements and a glue stick to adhere the paper elements. I added a bird's nest, some vintage letters, an egg with a word glued on it, a word printed on fabric and scraps of patterned paper.

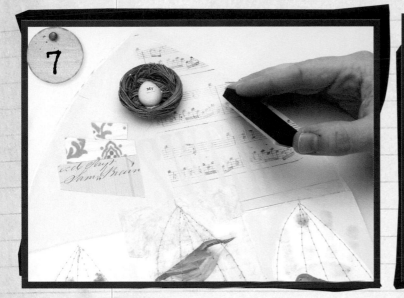

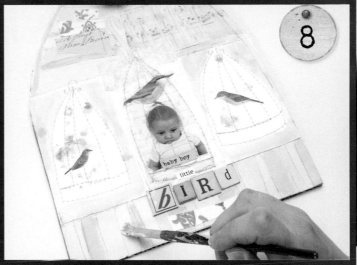

Stamp collage

Use a paintbrush to apply blue acrylic paint to foam letter stamps. Press the stamps gently onto the collage surface, creating the word of your choice.

Embellish with pencil and paint

Using a pencil, outline the stamped letters and draw handles onto the birdcages. Then add random pencil lines to accentuate any background areas. Once you've further defined your background with pencil lines, fill in some of the shapes and areas you've created using a paintbrush and Aquamarine and Yellow Ochre glazes. Allow a few minutes of drying time.

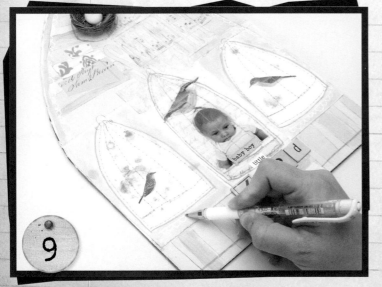

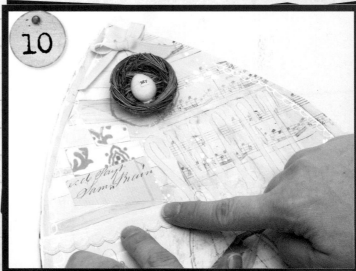

Layer paints

Draw additional details and add splashes of color using water-soluble crayons and a white gel pen. To add additional warmth or accents, feel free to brush glaze onto any of these areas, as well. Then finish this step by splattering a bit of white acrylic paint onto the collage.

Add final embellishments

Adhere any final embellishments to the collage with tacky glue. I added scalloped trim and a bow at the top of the arch. Also, since I created this collage as part of a book, I punched holes in the side so it could be tied onto other corrugated cardboard pages with bows. Of course, this is optional, depending on how you choose to display your collage.

COLLAGE ON FOAMCORE
the anguish of a mother's heart

Featured Techniques

- Incorporating symbolism
- Using words and phrases
- Layering paint
- Layering paper
- Splattering paint

materials

- foamcore
- craft knife
- paintbrush
- white gesso
- scissors
- collage images
- glue stick
- acrylic paints
- water to thin paints (optional)
- pencil
- water-soluble crayons
- about 14" (36cm) of ribbon
- 2 brads
- tacky glue

I am intrigued by tall, narrow shapes in my artwork.

Stacking different elements on top of one another is pleasing to me for some reason. So with this piece, I decided to go all out and make the whole piece tall and narrow. Since it is so much larger than my typical artwork, it needed to have a sturdier base, which is why I used foamcore.

I chose images to reflect my current situation, that of soon becoming the mother to two small children. The two rocking chairs represent the attentiveness I'll need to give these two babies, and the girl's photo is one that reminds me of myself as a young girl. The trees are a symbol of strength and growth; the two trees are feeding and nourishing each other, just as I feed and nourish my children, and they do me. I've used words to capture my emotions about my role: "The anguish of a mother's heart" is on the large tree, and "I am willing to" is on the girl. Although it is at times anguishing to be a mother, my love for my children makes me willing to do whatever is needed to care for them.

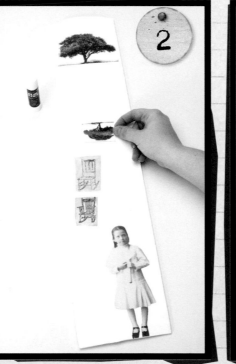

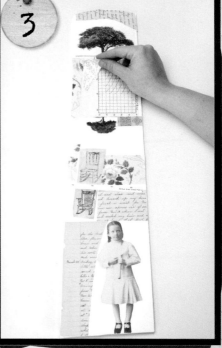

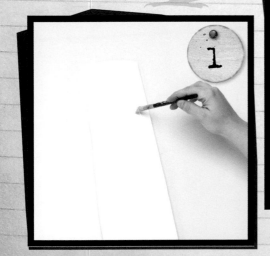

Prepare surface

Cut out a piece of foamcore with a craft knife to the desired shape. Use a paintbrush to add a coat of gesso to the slick surface to give it a tooth.

Arrange focal elements

Cut out and arrange your focal collage elements to your liking. Once you've positioned all your elements in a balanced way, adhere them to the surface with a glue stick.

Add secondary elements

Add some secondary elements—patterned scrapbooking papers, pages from old books, handwriting from an old journal—positioning them around the focal points of the piece. This enhances the composition, creates a bottom layer upon which to build the collage and introduces a color scheme to the piece.

Apply first layer of paint

With a paintbrush, start adding the first layer of acrylic paint. Here I started with a mauve color to play off of some patterned papers I used. I painted around the focal points and worked outward from there, overlapping the collage materials at times.

Apply second layer of paint

Incorporate another layer of paint on top of the first. Here I used an olive-gray to tone down the pink tones and draw out some of the darker colors from the older photos, which in this case were black and white with a subtle greenish tint. I was careful to let the mauve color show through in some areas, creating borders around some of the elements and blended effects in other areas.

Tone down colors

Using an off-white acrylic paint that is somewhat translucent (or watering down a thicker acrylic paint you have on hand), add layers of paint to any areas that need toning down. I've used it on some of the patterned papers and handwriting and also around the trees to warm them up a bit.

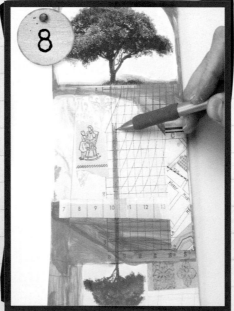

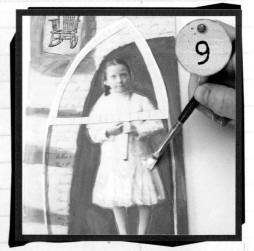

Layer collage elements

Layer some secondary elements on top of some of the painted areas. Here I used a glue stick to adhere words and images I had from vintage books, as well as scraps of patterned paper. I also used a craft knife to cut an arch out of colored cardboard and added it as a sort of frame to bring additional focus to the image of the little girl.

Pencil in details

Using a pencil, add some lines and shading to further define and connect existing collage elements.

Accent with paint

Add another dimension to the collage by outlining and accenting key areas with white acrylic paint. Here I painted white lines to give depth to existing pencil lines and to outline key words. I then carefully used a dry paintbrush to apply thin strokes of white paint to fill in the girl's dress.

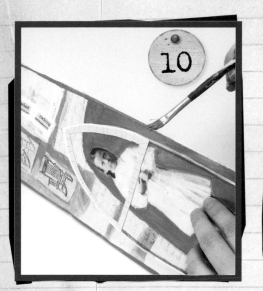

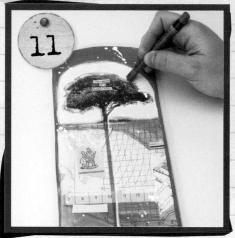

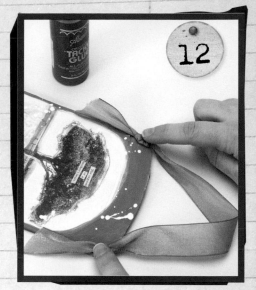

Define edges

Go back and add more olive-gray acrylic paint to further define the edges of the piece and to color the side edges of the foamcore.

Add final elements

Add finishing touches to complete the look of the piece. I adhered a few small final collage elements, splattered white paint lightly over the piece and used an ochre water-soluble crayon to further define the edges of the images with a hint of contrasting color.

Attach ribbon

Tie a knot near each end of the ribbon and use tacky glue to attach the ribbon near the top two corners of the piece. Push two decorative brads through the ends of the ribbon into the foamcore.

Tip

If you're layering paint over something but you want what's underneath to partially show through, either use a dry brush so you don't get full coverage or water down the paint to make it thinner and more translucent.

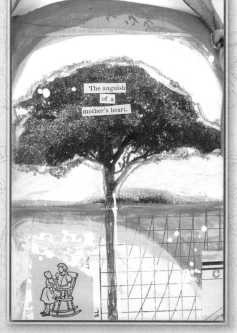

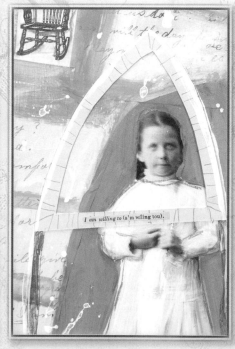

COLLAGE PHOTO FRAME
sweet child

sweet
sweet

child
child

Featured Techniques

- Layering paint
- Altering an ink-jet image
- Framing a photo
- Using a photo-shoot photo
- Using words and phrases

materials

- 5½" x 5½" (14cm x 14cm) square of wood
- triangle of wood cut slightly larger to fit on top
- tacky glue
- decoupage medium
- vintage wallpapers or patterned papers
- photo printed with ink-jet printer on photo paper
- water
- spray bottle
- paper towels
- scissors
- decorative embellishments
- acrylic paints
- paintbrush
- glue stick
- words cut from a book
- white gel pen
- pencil
- water-soluble crayons
- sandpaper, a sanding block or an electronic sander
- Golden Artist Colors glaze (Yellow Ochre)
- hammer
- 8 copper nails
- 4 metal box feet

Lately I've been creating photo frames

from blocks of wood. For this piece, I used a similar process, but instead of making it a frame from which the photo can be removed, I made it a "permanent" photo frame, with the photo attached. This is a favorite shot of my son, so innocent and sweet. I wanted to create a frame that reflected those emotions. I used sweet, childlike decorative papers and colors. The house motif has protective undertones yet is also whimsical and fun. One of my favorite things about the finished piece is that while it's very personal for me since it features Riley, it is also a very universal work that could appeal to a wider audience as representative of any child.

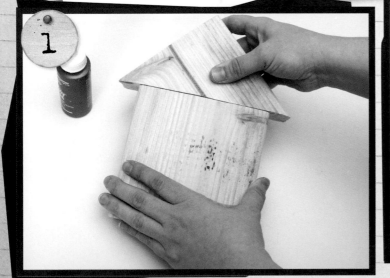

Assemble base

Glue the wooden square and triangle together using tacky glue or another strong adhesive.

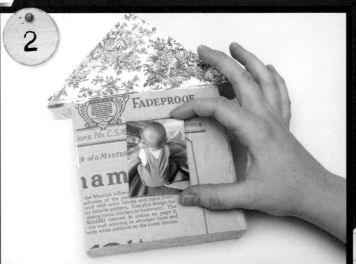

Establish background

Apply decoupage medium to the front side of the wood and cover it with pieces of decorative paper. Once you have established your background, start to envision where you want to place your photo, but do not adhere it to the surface.

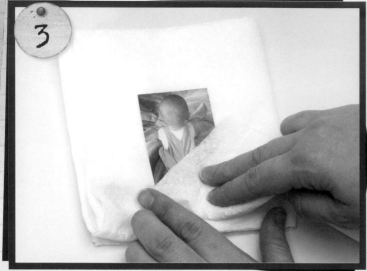

Alter photo

Spray the photo with water and use a paper towel to wipe some of it away and give it a faded look (see Altering an Ink-Jet Photo on page 44 for more on this technique).

Arrange collage elements

Cut out elements to surround the photo and start positioning them to decide upon your composition, but don't glue them down yet.

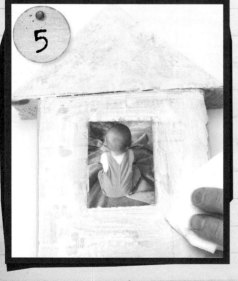

Apply paint

Remove the temporarily positioned elements from the collage and layer two colors of paint on top of the patterned background papers with a paintbrush (see Layering Paint on page 16 for more on this technique). Splatter water on the surface, wait a few moments and then blot it away to reveal spots of the first layer of paint. I used a yellow-green for the first layer and a pale blue for the second layer on the square piece, and an aquamarine color on the triangular piece. Allow a few minutes of drying time.

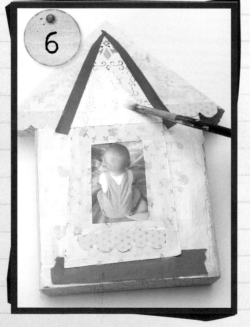

Adhere collage elements

Use a glue stick to adhere the elements you positioned in step 4. Apply paint to some of these papers, as well.

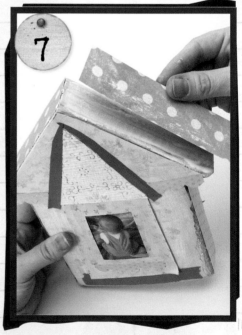

Cover sides of collage base

Cut additional patterned papers to cover each side of the wood, and adhere them with decoupage medium.

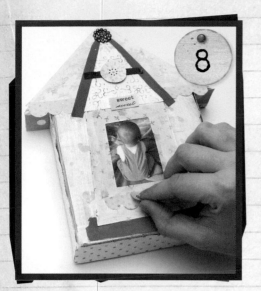

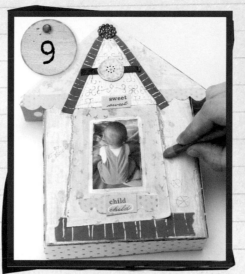

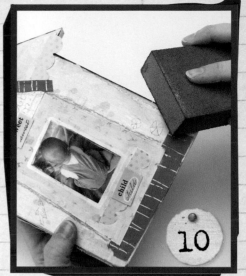

Adhere final embellishments

Adhere final elements to the collage. Here I added words, bits of metal and other decorative elements using a glue stick for the lighter items and tacky glue for the heavier ones.

Add details

Add detail by drawing lines and sketches with a white gel pen, a pencil, water-soluble crayons and a small paintbrush for any additional paint accents.

Sand collage

Use sandpaper, a sanding block or an electronic sander to smooth the visible corners where the edges of the wood block meet. This will wear off the hard edges of the wood and paper and make the final piece look more worn. Wipe clean.

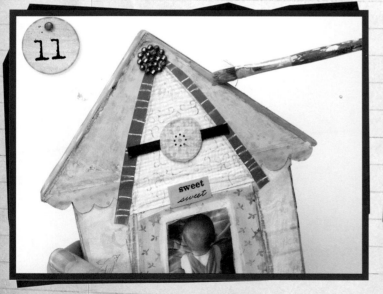

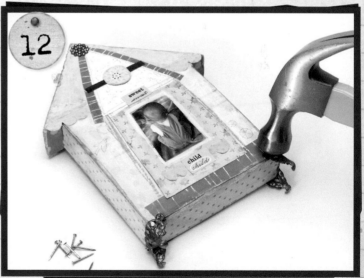

Apply paint to sanded areas

Use a paintbrush to apply Yellow Ochre glaze to the areas you sanded for a more finished look.

Attach feet to collage

Use a hammer and copper nails to nail the four metal box feet to the bottom of the piece.

VINYL SANDWICH COLLAGE

busy i must be

Featured Techniques

- # Incorporating symbolism
- # Using a modern photo
- # Extending the photo
- # Using words and phrases

Busy I must be, and do

(BCDE...JKLM...)

abcdefg...lmnop

nest

materials

- images and other collage elements
- 2 metal filigree embellishments
- beaded embellishments
- scissors
- colored cardboard
- glue stick
- tacky glue
- small twig
- patterned paper or vintage wallpaper
- small plastic egg
- 2 pieces of 10" x 14" (25cm x 36cm) clear vinyl (it comes in different thicknesses; opt for a thinner material)
- craft knife
- 12" (30cm) ribbon
- vintage game piece
- Golden Artist Colors glaze (Fresco Cream)
- 2 brads
- sewing machine (or needle if sewing by hand)
- thread in a coordinating color of your choice
- acrylic paint
- paintbrush
- paper towels
- tissue paper
- page from a vintage book

I often think of mothers as being

like birds, caring for their eggs and making sure they have a protective nest in which to live. I wanted to represent that in this piece of art. So, using a photo of myself, I created a "Corey Bird," perched on a branch, looking down upon my nest with two eggs. Because I was combining both two-dimensional elements and three-dimensional elements, I decided to encase them all in vinyl so everything felt contained. The words I found in a vintage book, "Busy I must be, and do," seemed the appropriate finishing touch.

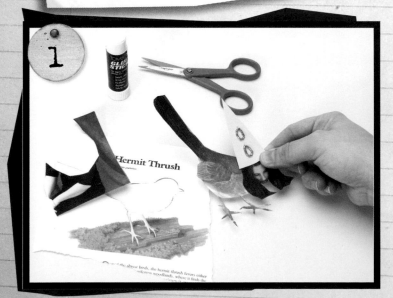

Create altered image

Choose a photo or image of a bird and a photo of your face that are proportional in a way that the face could fit onto the bird's body, and carefully cut the images out. Cut a piece of colored cardboard into the shape of a hat and embellish it with decorative accents. Then use a glue stick to adhere all three pieces together to create a new altered image.

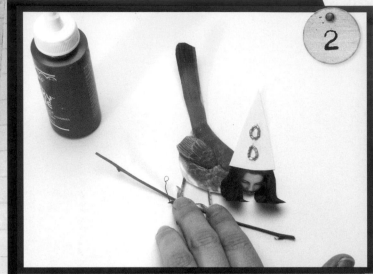

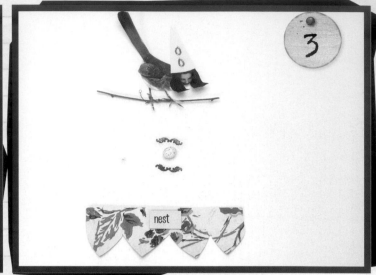

Combine collage elements

Use tacky glue to adhere the bird to the twig.

Arrange design elements

Now that you've created your main subject, cut background shapes from vintage wallpaper or patterned paper and start arranging your main collage to decide upon a color scheme, theme and composition. I chose an egg and the word "nest" to further illustrate the bird theme. I decided to create my collage in three sections on vinyl.

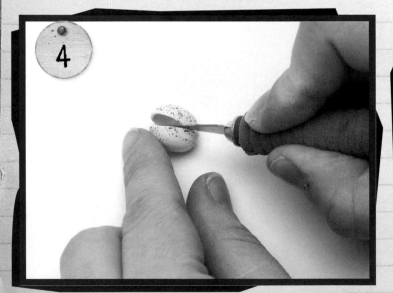

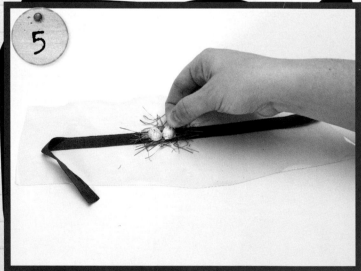

Modify elements to fit collage

To make the egg representative of two children, I used a craft knife to cut it in half.

Arrange one section of collage

Cut a piece of vinyl and lay it down as your background surface for one section of the collage. Arrange the collage elements for this part of the piece on top of the vinyl and adhere them with tacky glue. Here I used a strip of ribbon, created a nest to hold the eggs and numbered the eggs.

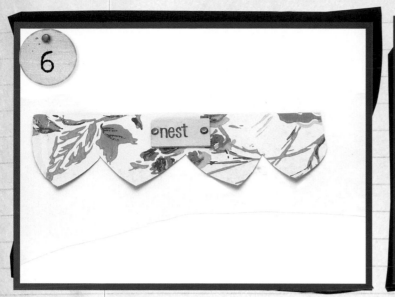

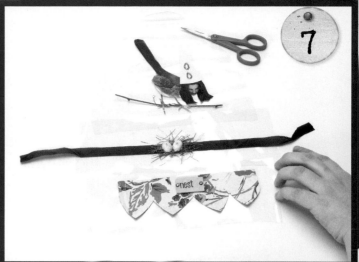

Arrange a second collage section

Repeat this step using another piece of vinyl and the elements for the next section of the collage. I added vintage wallpaper, a game piece that I coated with some Fresco Cream glaze to make it appear aged, and some decorative brads.

Assemble collage pieces

Repeat this step one more time for the final section of the collage, adhering the main subject to a third, larger piece of vinyl. Arrange all three pieces of vinyl as you want them to connect, decide upon a shape for the piece as a whole and trim accordingly. Allow for overlap to sew the pieces of vinyl together, and remember you can always trim more later. Use a couple of dabs of glue stick to temporarily hold the pieces in position.

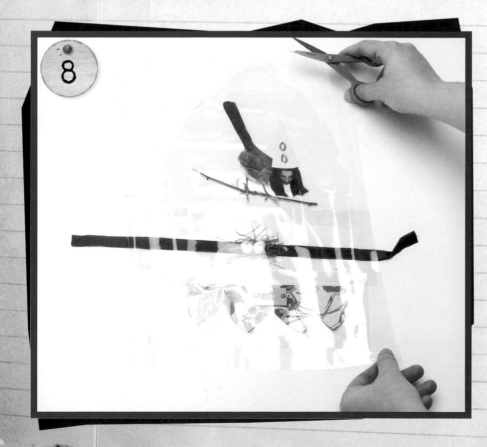

Cut top layer to size

Cut a piece of vinyl that is larger than the entire collage. This will be the top layer of the vinyl sandwich; you can cut it to the exact shape you need later.

Sew layers together

Using a sewing machine or a needle and thread, hold the top sheet of vinyl firmly on top of the collage and sew horizontally across the bottom sections to connect them where they overlap. Then sew all the way around the edge of the piece, being sure to start at the top and leave a long thread that you can later use to hang the collage.

Tip

The heat of the sewing machine and the stickiness of the vinyl can make this difficult, but be patient. For ease of motion, use larger stitches. Try to pull the vinyl through the machine rather than letting the machine naturally feed it through; this will help prevent it from getting stuck. Don't worry about backstitching, because your lines of stitching will interlock, helping to hold one another in place. I usually let any thread ends dangle for a slightly less refined look. If you're sewing by hand, this process will be a bit easier but will take much longer.

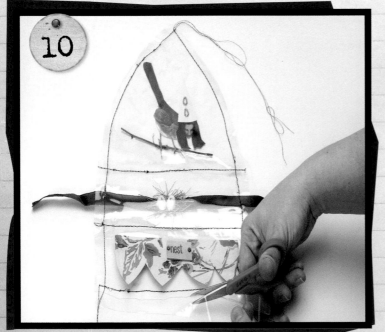

Trim vinyl

Trim the vinyl close to the stitches to refine your shape. Be careful to avoid accidentally cutting the hanging threads if you like the loose look of them.

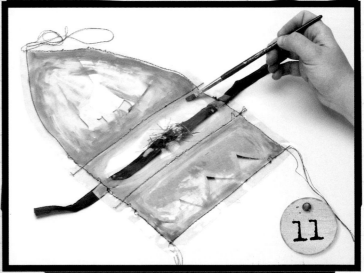

Apply paint

Lay the piece facedown and, using acrylic paint in a coordinating color, brush random strokes around the edges, inside the sewing lines. Flip the piece over and take a look at your progress from the front. If you have more paint than you want, take a wet paper towel and wipe some of it away until you create the look you desire.

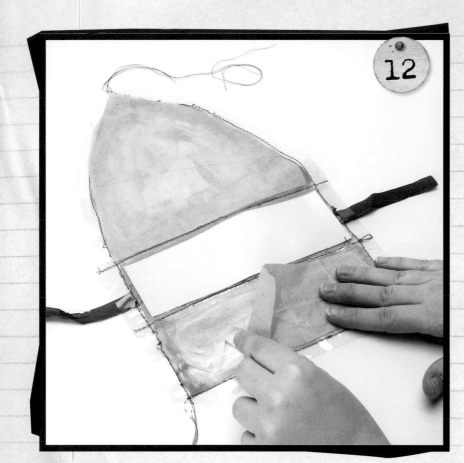

Adhere background elements

Cut tissue paper, vintage book pages or any other paper you want to use as the background layer to the appropriate sizes. Adhere them to the back of the piece with a glue stick.

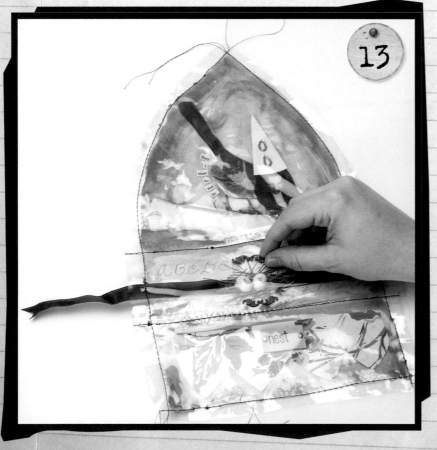

Add final embellishments

Use tacky glue to add any final embellishments to the front, and use a glue stick to add any words you'd like to include. Trim the ends of the ribbon if you wish, and tie a knot in the thread at the top to create a hanger for the piece.

CiGaR BOX COLLaGe
down in seattle, near all the cattle

His name was Riley, and he was smiley, as he sat in his little, red coupe.

Down in Seattle, near the cattle, I met a boy who was so cute.

COW

Featured Techniques

- Incorporating symbolism
- Using words and phrases
- Glazing
- Splattering paint

materials

- cigar box
- acrylic paints
- paintbrush
- images and other collage elements
- glue stick
- paper doll
- paper-doll outfit
- scissors
- pencil
- foamcore
- tacky glue
- vintage flashcard
- patterned paper or wallpaper
- Golden Artist Colors glazes (Fresco Cream and Yellow Ochre)
- water-soluble crayons
- water for thinning paints (optional)
- toy cow

The piece is about a special song I sing to

my son Riley. It's a Patsy Cline song that I've altered a bit to fit our lives. When he was born, we lived near Seattle, and there was a farm directly behind our house where cows grazed. The view from his nursery was of this farm. The lyrics I sing are: "Down in Seattle, near all the cattle, I met a boy who was so cute. His name was Riley, and he was smiley, as we sat in his little red coupe." When I sing this song it always makes him smile, so I wanted to create a special piece of art that was a little more "substantial" than a flat collage. I decided to make a shadowbox in an altered cigar box, so it would have both literal and figurative depth and dimension. I pulled several elements from the song to illustrate in this piece, including cow references, a little boy and an antique car drawing of "his little red coupe."

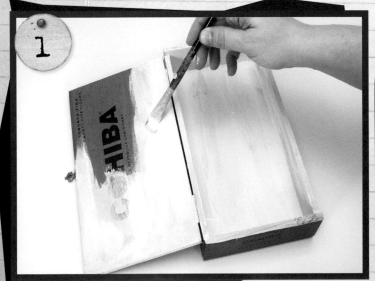

Prepare surface

Using a paintbrush, coat the inside of the box and the lid with off-white acrylic paint.

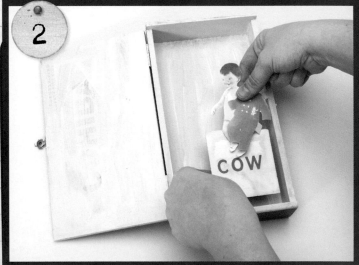

Arrange main collage elements

Decide where you want to position your main collage elements, but do not yet adhere them to the box. Here I also glued the outfit onto the paper doll using a glue stick.

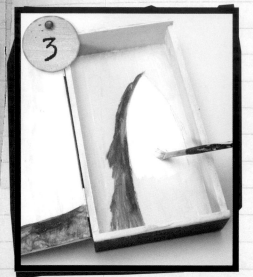

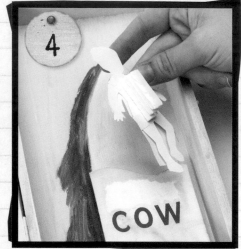

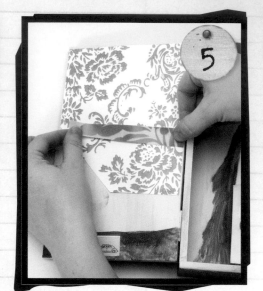

Add background details

Once you've determined the placement of your main collage elements, add some appropriate background details to the inside of the box before gluing them in. Here I used a pencil to sketch some shapes that would frame and define the main subject, and then painted in and around them. Allow a few minutes of drying time.

Create dimension by raising some elements

Cut some pieces of foamcore to fit behind the collage elements. Use white tacky glue to adhere the foamcore to the back of the collage elements, and then to adhere them to the inside of the box. I used one layer of foamcore on the back of the vintage flashcard and three on the back of the little boy to create a three-dimensional effect inside the box.

Add decorative papers

Cut images and pieces of patterned paper to fit inside the box and on the inside of the lid, and adhere them to the painted wood with a glue stick. Here I used old wallpaper, selecting patterns with colors that matched those of the main collage elements, as well as a vintage image from a book.

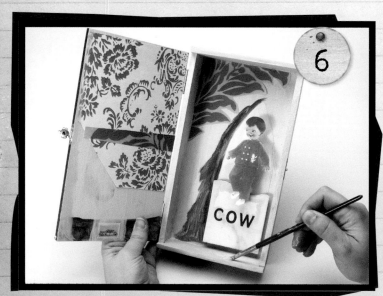

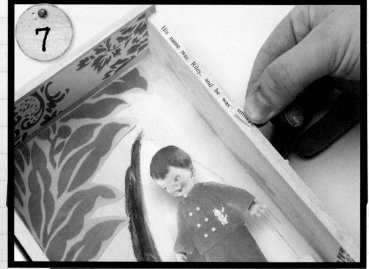

Apply paint

Apply an accent color of acrylic paint around the edges or wherever you feel it will be most effective in balancing the prominent colors of the collage. Allow a few minutes of drying time.

Layer collage elements

Using a glue stick, adhere additional pieces of the paper used on the lid to the inside sides of the box to further tie the two portions of the project together. Add words or phrases you want to emphasize to the outer edges of the inside of the box. In this case, I typed the lyrics to the song and printed them out on my printer.

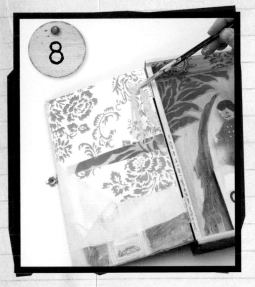

Add glaze

Brush Fresco Cream glaze over any elements you want to tone down in brightness. Here I glazed everything but the main subjects to make the collage look a bit more aged.

Add highlights with paint

Brush a bit of Yellow Ochre glaze over any small spots you'd like to brighten. Here I glazed the words and a portion of the background. Allow a few minutes of drying time.

Add final collage elements

Adhere any final collage elements to the box. Here I added some blue paper stars and a little name tag for the paper doll with a glue stick, and a piece of vintage trim with tacky glue.

Add details with paint, crayons and pencil

Add any finishing touches: I used yellow and blue water-soluble crayons to add some outlines and scribbles, splattered white acrylic paint and drew fine detail lines with a pencil.

Paint the outside of the box

Coat the outside of the box with off-white paint and let dry.

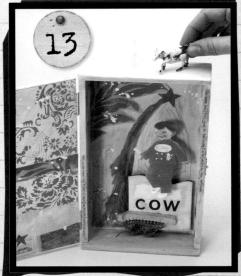

Add figurine

Glue a final embellishment, in this case a toy cow, onto the top of the box with tacky glue.

vinyl art doll
weariness, elation

Featured Techniques

- Using a photo-shoot photo
- Extending a photo with collage
- Incorporating symbolism
- Splattering paint

materials

- image of subject
- scissors
- muslin or a similar fabric
- matte medium
- paintbrush
- sewing machine (or needle if sewing by hand)
- thread in a coordinating color
- fiberfill stuffing
- bird images or other symbolic collage elements
- approximately 10" (25cm) of ribbon
- tacky glue
- bulldog clip
- acrylic paint
- water for thinning paints (optional)
- paper towels
- 10"-12" (25cm-30cm) vinyl
- small piece of thick paper
- words cut from a book
- embossed wallpaper or patterned paper, in a fairly neutral color and design
- 6" (15cm) of coordinating ribbon

I created this doll shortly after finding out

I was pregnant with my second son, and though I was incredibly excited, I was also beginning to realize the work I was in for. The piece is symbolic in a few different ways. The birds represent my two children, who are being protected in the birdcage. But the cage is also part of me, an extension of my womb. I chose to work with the vinyl so I could obtain the three-dimensional feel I wanted, with the birds actually enclosed in the cage. For the same reason, I put my image on fabric and created a doll. The words on my chest reflect the conflicting emotions I was feeling.

Prepare image

Choose a photo of yourself or another female subject that pictures the subject fully from the waist up. Cut around the outline of the image.

Adhere image to cloth

Cut a piece of muslin into two rectangles slightly larger than the subject. Coat the back of the image with matte medium and adhere it to one of the pieces of muslin. Then coat the top of the image and the entire surface of the muslin with matte medium. Let this dry for about five minutes.

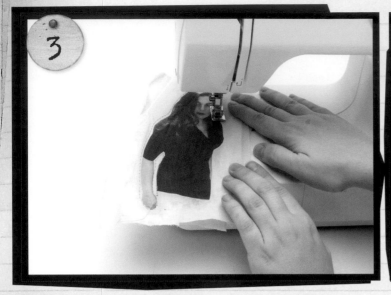

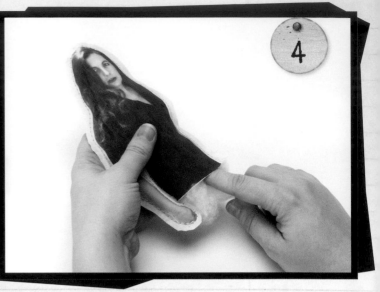

Sew top of doll

Put the two pieces of fabric together, one on top of the other, and use a coordinating thread and a sewing machine or needle to sew around the outline of the image, leaving the bottom edge open. (If you have a thin appendage as part of your image, as shown here, you might consider leaving a small opening for ease of stuffing there, as well.)

Stuff top of doll

Cut around the outline of the image, leaving about ¼" (6mm) fabric around the seam. Stuff the image with fiberfill stuffing until it has form and then leave the bottom open—we will glue this later.

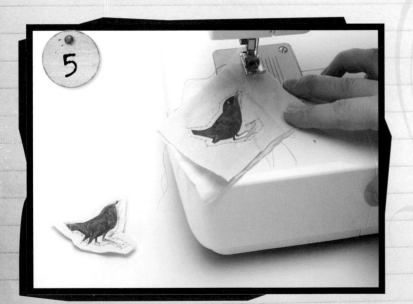

Sew remaining collage elements

With your two bird images or other symbolic collage elements, repeat steps 1–4. Then sew up the stuffing openings.

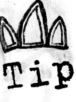

Tip

This image was printed on an ink-jet printer, which, as illustrated on page 42, means that it is water-soluble, so the matte medium might distort the color a bit. If you want to avoid this, select a non-ink-jet image for your project.

Tip

If you'd prefer not to glue your focal image to muslin, you can also buy special fabric for your ink-jet printer and print the image directly on the fabric. You can also transfer the image to the fabric with water, as shown on page 42.

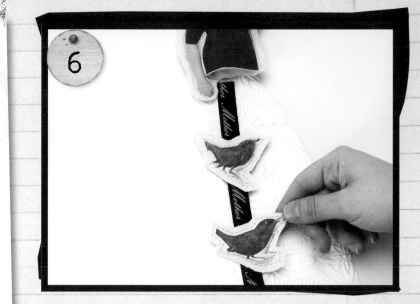

Arrange bottom of collage

Cut out a piece of embossed wallpaper or patterned paper in the shape of a skirt that would proportionately fit your subject. Start deciding what you want your composition to look like, arranging the main collage items on top of the skirt.

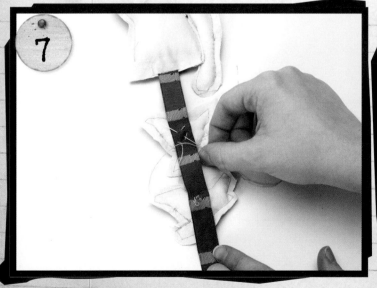

Join top and bottom of collage

Start adhering the main elements of your composition together. Here I sandwiched the 10" (25cm) strip of ribbon in between the bottom two pieces of the main subject and adhered all three pieces with tacky glue, being sure to completely seal up the opening to hold the stuffing inside. (Hold this together with a bulldog clip until it's dry.) I then stitched the two birds to the ribbon with a needle and thread.

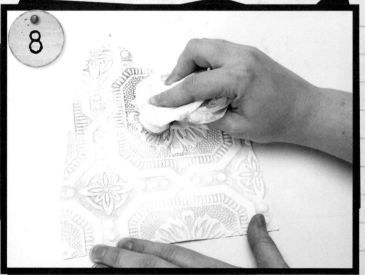

Add paint

Using a paintbrush, apply paint to the embossed wallpaper dress to add color and emphasize the paper's texture. I used a watered-down brown acrylic paint, brushed it onto the dress, and then wiped and blotted some of the paint from the surface with a paper towel to create an even more muted look. Finish by splattering paint on the surface of the skirt and then blotting the splatters to add even more texture.

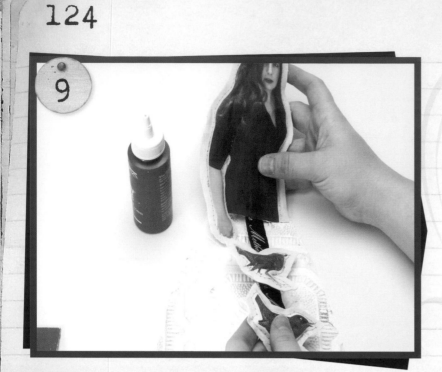

Adhere additional elements to bottom of collage

Apply tacky glue to the back side of the bottom edge of your main subject. Adhere the skirt to the subject, leaving the ribbon and the other collage elements to dangle freely on the front side of the paper skirt.

Tip

If there are any areas of your subject needing more dimension or shape, you can add a few stitches to better define the form. In this case I used this trick to define the arm a bit.

Trim vinyl to size

Cut a piece of vinyl to fit over the paper skirt. The top of the vinyl, near the waistline, should be exactly the size of the skirt, while the bottom of the vinyl should be about ½" to 1" (1cm to 3cm) wider than the skirt on each side.

Embellish vinyl

Using a sewing machine or a needle and thread, sew five evenly spaced vertical lines down the vinyl and one horizontal line across the bottom of the vinyl to simulate the shape of a birdcage.

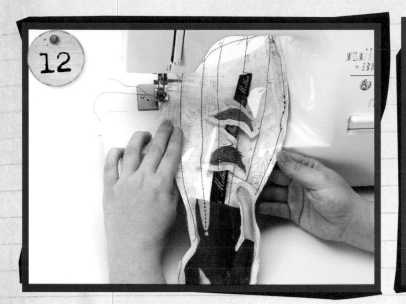

Attach vinyl to collage

Following very closely along the edge of the vinyl, sew the vinyl onto the right and left sides of the embossed wallpaper skirt. The excess vinyl will gather over the middle of the skirt at the bottom.

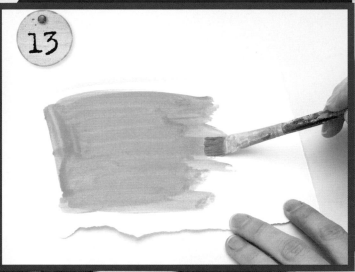

Create collage base

Cut a piece of stiff paper to a size slightly larger than the base of the skirt, and paint it with a coordinating color of acrylic paint on both sides. Let dry.

Attach collage base

Sew the base onto the bottom of the skirt and trim away the excess paper. This step can be difficult, but be patient with your stitches, and it will come together.

Add final embellishments

Add final embellishments. Here I adhered words to the front of the doll with matte medium, and then sewed a loop of ribbon to the top for a hanger.

inDEX

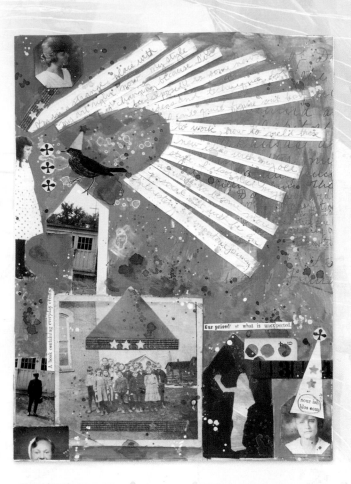

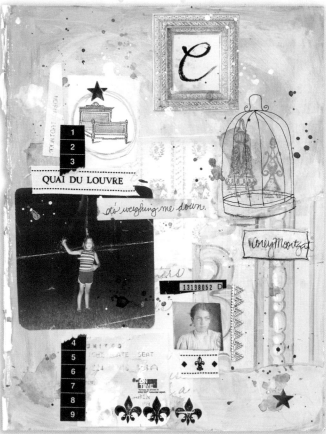

Indulge your creative side with these inspiring North Light Books!

Collage Lost and Found
Josie Cirincione

Inside *Collage Lost and Found*, you'll learn how to find and use old photographs, memorabilia and ephemera to create collages based on your heritage. Using her own Sicilian background as an example, author Josie Cirincione shows you how to examine your own heritage for inspiration, as well as tips on where to look and what to look for. Then you'll choose from 20 step-by-step projects that use basic collage, jewelry-making and image transfer techniques to make sassy projects to decorate with, wear and give away as gifts.

ISBN-10: 1-58180-787-2
ISBN-13: 978-1-58180-787-5
paperback, 128 pages, #33461

Visual Chronicles
Linda Woods and Karen Dinino

Have you always wanted to dive into art journaling, but you're always stopped by what to put on the page? *Visual Chronicles* is your no-fear guide to expressing your deepest self with words as art, and artful words. You'll learn quick ways to chronicle your thoughts with painting, stamping, collaging and writing. Friendly projects like the Personal Palette and the Mini Prompt Journal make starting easy. You'll also find inspiration for experimenting with colors, shapes, ephemera, communicating styles, symbols and more!

ISBN-10: 1-58180-770-8
ISBN-13: 978-1-58180-770-7
paperback, 128 pages, #33442

Expressions
Allison Tyler Jones and Donna Smylie

Whether you're a scrapbooker, amateur photographer, papercrafter or memory artist, this behind-the-camera guide shows you how to snap extraordinary photos of ordinary life. Authors Donna Smylie and Allison Tyler Jones show you inspiring ways to inject meaning and emotion into your portrait photos. Each chapter includes a sampling of stunning photo display projects to inspire you to creatively showcase your images.

ISBN-10: 1-58180-909-3
ISBN-13: 978-1-58180-909-1
paperback, 128 pages, #Z0526

Kaleidoscope
Suzanne Simanaitis

Get up and make some art! *Kaleidoscope* delivers your creative muse directly to your workspace. Featuring interactive and energizing creativity prompts ranging from inspiring stories to personality tests, doodle exercises, purses in duct tape and a cut-and-fold shrine, this is one-stop-shopping for getting your creative juices flowing. The book showcases eye candy artwork and projects with instruction from some of the hottest collage, mixed media and altered artists on the Zine scene today.

ISBN-10: 1-58180-879-8
ISBN-13: 978-1-58180-879-7
paperback, 144 pages, #Z0346

These and other fine North Light titles are available from your local art and craft retailer, bookstore or online supplier.